ART AND HISTORY
LISBON

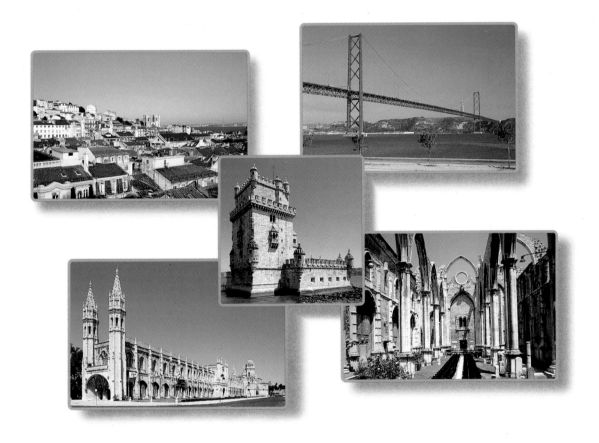

Text by
EMÍLIA FERREIRA and JORGE CABELLO

BONECHI

INDEX

Publication created and designed by Casa Editrice Bonechi
Publication Manager: Monica Bonechi
Picture research and Graphic design: Serena de Leonardis
Editing: Anna Baldini
Cover: Sonia Gottardo
Make-up: Simone Romiti
Map: Studio Grafico Daniela Mariani - Pistoia

Text: Emília Ferreira *and* Jorge Cabello.

© Copyright by CASA EDITRICE BONECHI -Via Cairoli, 18/b - 50131 Florence - Italy
E-mail: bonechi@bonechi.it - Internet: www.bonechi.it

Printed in Italy by the Centro Stampa Editoriale Bonechi.

Photographs from archives of CASA EDITRICE BONECHI *taken by* Paolo Giambone;
pages 68, 76, 77, 82, 112 below, 113, 119, 120, 123: Luigi Di Giovine; *pages 5 above, 11 below, 99, 104 above, 110, 122 above:* Jean-Charles Pinheira.

Photographs from EDITORIAL SOFOTO, LDA:
pages 79 above, 81, 115, 116 above: © Paulo Sotero; *page 105:* © Chester Brummel

Photographs kindly supplied by Arquivo Nacional de Fotografía - INSTITUTO PORTUGUÊS DE MUSEUS:
pages 62, 63, 64, 65: Museu Nacional do Azulejo;
pages 71, 72, 73, 74: Museu Nacional de Arte Antiga;
page 89 above right and middle: Museu Nacional de Arqueologia;
page 101: Museu Nacional de Etnologia.

Photographs kindly supplied by Fundação Calouste Gulbenkian - Museu: *page 106, 107, 108, 109, photos taken by* Reinaldo Viegas.

ISBN 88-8029-394-X

* * *

INTRODUCTION

*L*isbon, a city which has lived through both fabulous wealth and extreme poverty, thrived on account of the river Tagus. Thanks to the river, the city has been loved and assaulted since the days of the first Stone Age settlement. Built on and surrounded by hills, Lisbon today guards countless splendours and memories and is a city whose charm is impossible to resist, despite the hectic pace of modern life and the nerve shattering traffic. Lisbon has seen many different peoples and races, and her history can be traced back to the most distant past. If, however, the vestiges of the city's earliest inhabitants are few and indistinct, several good reasons account for this fact, such as newer buildings being built on the foundations of older ones over the centuries - those of the victorious invaders taking the place of those of the defeated occupants - as well as devastation and damage wreaked by countless earthquakes and fires.

However, apart from its archaeological attractions, Lisbon's magic has always been confirmed by the many visitors who have spoken of it throughout history.

Thanks to its strategic position - the lie of the land, the wide, calm river flowing into the Atlantic, the good water supply, the fertility of the land and the temperate climate - it has always been a popular place to drop anchor, and was a prosperous maritime and trading post as long ago as 1500 B.C..

The list of Lisbon's inhabitants, which begins rather vaguely (we only know that the original occupants were nomads that settled here during the Stone Age) includes the Iberians, the Ligurians and the Celts. The latter seized power from the Iberians, mixed with the conquered people and so the Celtiberian race was born. Then came the Libyans and the Phoenicians, who around 1200 B.C. gave the city the first name to be recorded in the annals: Alis-Ubbo - pleasant haven. Nearly six centuries later, the Greeks arrived. They named the city on the Tagus Olisipo, either after Elosipon, a demi-god of Atlantis, or after Elasippos, driver of horses.

In 238 B.C., led by Hamilcar, the Carthaginians arrived, but a mere thirty-seven summers later the Romans came on the scene, and started a reign which was to last for six long centuries, during which Alis-Ubbo became Olisipo Felicitas Julia *in honour of Julius Caesar.*

Lisbon always seems to have held a particular appeal, as Norberto de Araújo writes in his Peregrinações em Lisboa, "the Alisubbo that the governors of Rome found in 201 B.C. was not the same city as they lost at the dawn of the fifth century, when the Germano-gothic Barbarians defeated them. The genius of Rome was enough to make Olisipo wealthy, this, a city which while it was not a great metropolis of Roman Hispania, had, like no other city, a power to seduce, which

explained its constant development: the river and the Ocean twenty oar strokes away." As an administrative centre, the city was made the only oppidum civium romanorum *in Lusitania,* giving its inhabitants the same rights as Roman citizens. It was also important as a centre of ship building, the city being linked to Bracara and Emerida Augusta - Braga and Mérida, respectively - by military roads.

After this period, traces of which can still be found, other peoples let themselves be tempted by the delights of the peninsula, and of Olisipo in particular.

In the fifth century, the Barbarian invasions began. Vandals, Swabians, Alans and other races ruled successively. The Alans took the city from the Romans, but did not stay long. Then followed the Visigoths when the city was known as Olisipone, at the time of the conquests and defeats by the Visigoths and the Swabians. Both the inhabitants and the architectural splendours of the Roman past were gradually sacrificed amidst unending strife. Around 472 A.D., an earthquake is believed to have put an end to what was left of the Phoenician, Carthaginian and Roman cities. Peace finally came to Olisipone, *now Christian,* under the rule of the converted Visigoths.

Arab forces, headed by Abdelaziz Ben Musa, entered the city in 714, marking the beginning of nearly four hundred years of Arab domination. In spite of the battles, which they also had to face and which continued to flare up, the Arabs brought with them the riches of a great civilisation. Now called Lissibona or Aschbouna, the prosperity of the city was reflected in the mosques built where churches had previously stood, such as on the site of the present Sé, or cathedral, and in the surrounding countryside. Thus Lissibona *became the* envy of the Christians, who often dreamed of retaking the city.

This, however, was not to prove an easy task. Despite the fact that there was only one castle, attacks on Lisbon were extremely tricky thanks to the maze of city streets built by the Arabs, squeezed between the city walls which at that time came down as far as the river (there were then many more entrances from the river than there are now, as demonstrated by the fact that there was a Roman quay in what is now Rossio). Only in 1147, three years after the kingdom of Portugal was founded, Afonso Henriques (1128-1185), supported by German, English and Flemish crusaders on their way to the Holy Land, finally reconquered the city after a twelve-week siege.

The city also grew under the Christians who filled it with monuments, and built churches on the ruins of mosques, turning them into parish churches, such as the Sé, Santa Cruz do Castelo, São Bartolomeu or Santiago.

In the middle of the thirteenth century, during the rule of Afonso III (1210-1279), Lissibona was made capital,

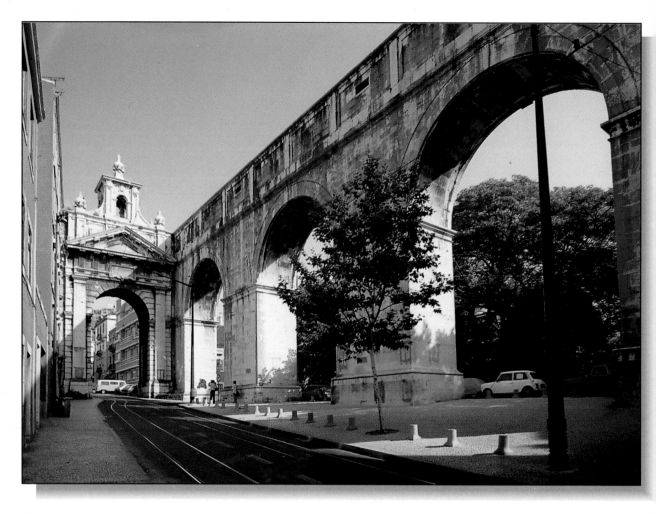

Águas Livres Aqueduct (1728).

supplanting Coimbra. The city was transformed with Gothic splendour a style already flourishing in Portugal. Examples of this are the convents of São Domingos, São Francisco and Santa Clara, besides other more modest buildings. It was also during this time that the first palaces were built, such as Alcáçova.

Lissibona expanded and started to outgrow the city walls. The monarch and poet, Dinis (1261-1325) recognised the need to push out the boundaries of the city and ordered a new stretch of wall to be built, which came to occupy part of the Praça do Município of today. Later, in the mid fourteenth century, King Fernando (1367-1383) decided to build a new city wall. Using part of the boundary extended by the troubadour king, he continued it so as to surround the whole city. In fact, some years later this protection proved extremely useful to the Master of Aviz (1357-1390), whilst defending the city against King João I of Castille.

The sixteenth century, the age of the Discoveries, saw the city expand even more. Lisbon grew rich on oriental spices, which financed building on an increasingly grandiose scale. Peoples from around the world - a tenth of the population were slaves - mingled in the streets. During the reign of Manuel I (1469-1521), the medieval city started to adapt to the new era. Large Renaissance-style houses were built for noblemen. However, time stands still for no man: on top of these still quite modest residences, bigger Baroque palaces were built. This was a time of imposing architecture, revealing a taste for grandeur of scale and design.

It is from King Manuel that the late Portuguese Gothic style, the Manueline, derives its name. It is a blend of European and North African influences, incorporating some maritime elements.

These were times of national glory and euphoria for Portugal. Later, after 1580, during the six long decades of Spanish rule, the city sank into total decadence.

Lisbon reflected the poverty which swept the country in a radical change of fortune, even after the restoration of independence on 1 December 1640.

In the first half of the eighteenth century, during the reign of João V (1706-1750), ornament outshone architecture as an art form, exemplified by gilt carving and tiled walls and floors. When, mid-century, the great earthquake shook Lisbon on 1 November 1755, the city presented an extraordinary mixture of styles and colours, still keeping to the maze-like street plan inherited from the Middle Ages. However, after the violent earthquake, which was followed by a tidal wave and devastating fires, the city did not waste time before rebuilding, gal-

vanised by the enlightened spirit and disciplined by the dictatorial power of the Prime Minister, Marquês de Pombal.

The nineteenth century saw the arrival of the industrial revolution, which brought about innumerable changes - politically and economically as well as socially. The revolution spread all over Europe, reaching Portugal, and Lisbon was also witness to its effects.

In 1807, French troops commanded by Junot occupied the capital, forcing the royal family into exile in Brazil. Despite the political instability, which came to a climax on 24 July 1833, when the liberal army entered the city, Lisbon's seven hills, traditionally considered to epitomize the capital, were joined by others previously considered suburban areas. Areas such as Estrela, Belém, Alcântara and Ajuda thus became integral parts of Lisbon. At the end of the nineteenth century, Avenida da Liberdade, substituting the Public Promenade built by the Marquês de Pombal, opened the way for new urban expansion, which still continues today, offering more and more hills to the ever young "bride of the Tagus" - Lisbon.

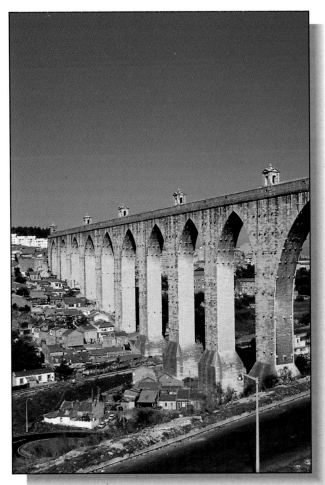

The Aqueduct over the Alcântara Valley.

Terreiro do Paço on a tile panel depicting Lisbon before the 1755 earthquake.

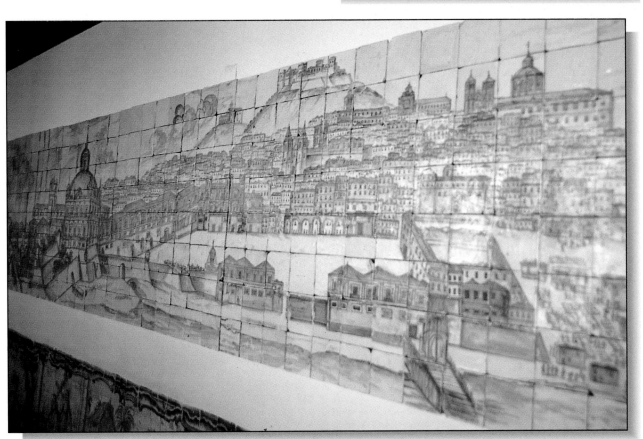

5

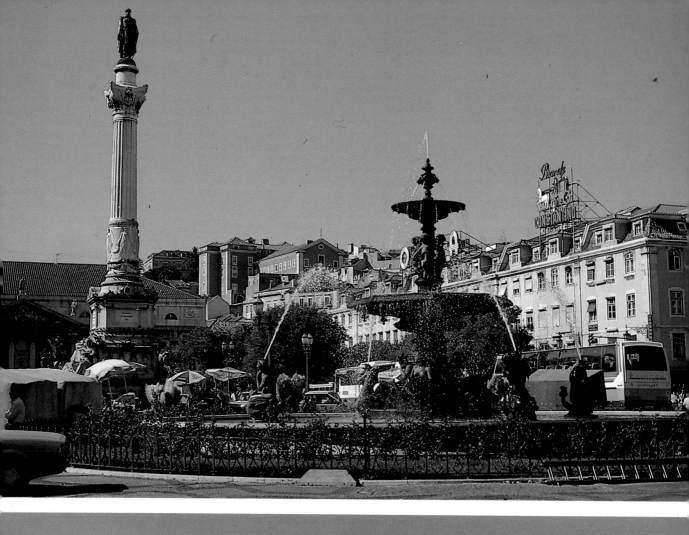

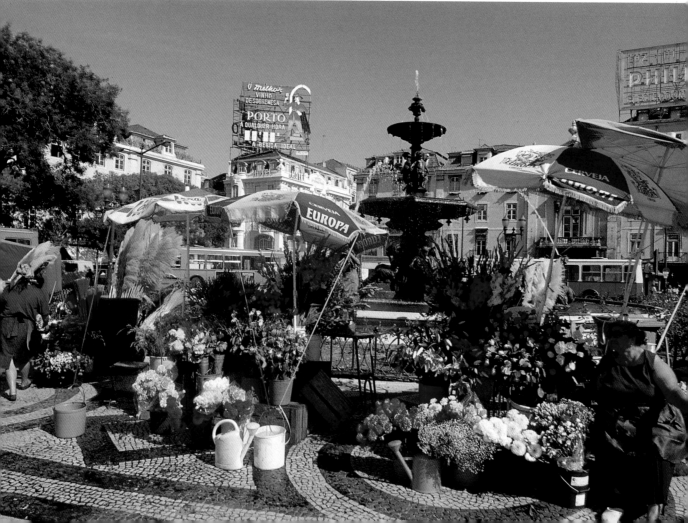

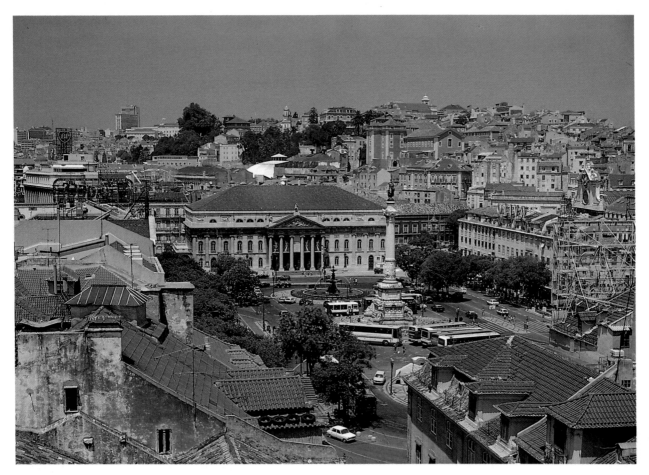

Rossio Square also known as Praça D. Pedro IV, was originally planned by the Hungarian Carlos Mardel.

Flower sellers on Rossio Square.

Following pages:

Column with a bronze statue (1870) of D. Pedro IV. The four figures on the plinth symbolize Justice, Wisdom, Courage and Restraint.

One of the two Baroque fountains on Rossio Square.

ROSSIO

Rossio means a large open area, used by the populace. Lisbon's Rossio, (its official name is Praça D. Pedro IV), seethes with activity. Different parts of the city converge on the Rossio, which is the gateway to both the river and Lisbon's avenues. The look of the square has altered several times, the last change being when trees were cut down and the pedestrian area was reduced. Much of the traditional mosaic pavement area was also dug up, so as to make way for roads, first for trams, and later for buses.

At the north end of the square stands the **Dona Maria National Theatre**, built in 1842/46 to designs by Fortunato Lodi, thanks to the campaigning efforts of Almeida Garrett. Burnt down in 1964, it reopened to the public in 1978. Crowning the theatre's pediment is a statue of Gil Vicente, the sixteenth-century playwright, considered the father of Portuguese theatre.

On the same spot in the fifteenth century stood the Estaus Palace where King Pedro received foreign dignitaries. Later, the palace was taken over by the Court of the Inquisition. Severely damaged in 1755, it was occupied again in the nineteenth century and used for several different purposes. In 1836, when the Public

Treasury was housed in the building, fire destroyed it completely.

In front of the theatre, the square contains two fountains which guard the graceful column supporting the statue of Pedro IV. He became King of Portugal in 1826, following bloody battles with his brother. Earlier, in 1822, he declared Brazil independent and reigned as emperor until 1831. There are those who consider the monument to be that of another emperor - the Austrian Maximilian, whose statue remained in Portugal when he was executed by Mexican patriots. As Maximilian and Pedro IV were generally represented in similar fashion, and considering that nobody really looks up that high, the statue stayed where it was.

The south side of the square is bright with flower sellers and their stalls. The buildings on this side date from the eighteenth century reconstruction of the city. There are banks, bookshops, telephone facilities, cafés - Nicola, with the statue of the poet Bocage, and Suiça are the most famous - shops and old-fashioned hotels. Exactly opposite the theatre is the small **Bandeira Arch**, built by the businessman Pires Bandeira at the end of the eighteenth century.

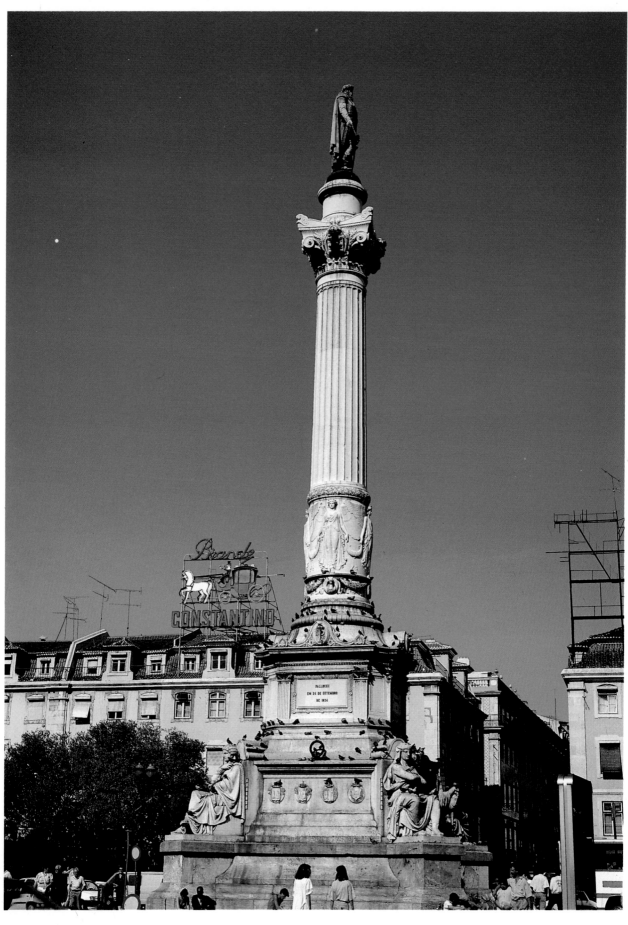

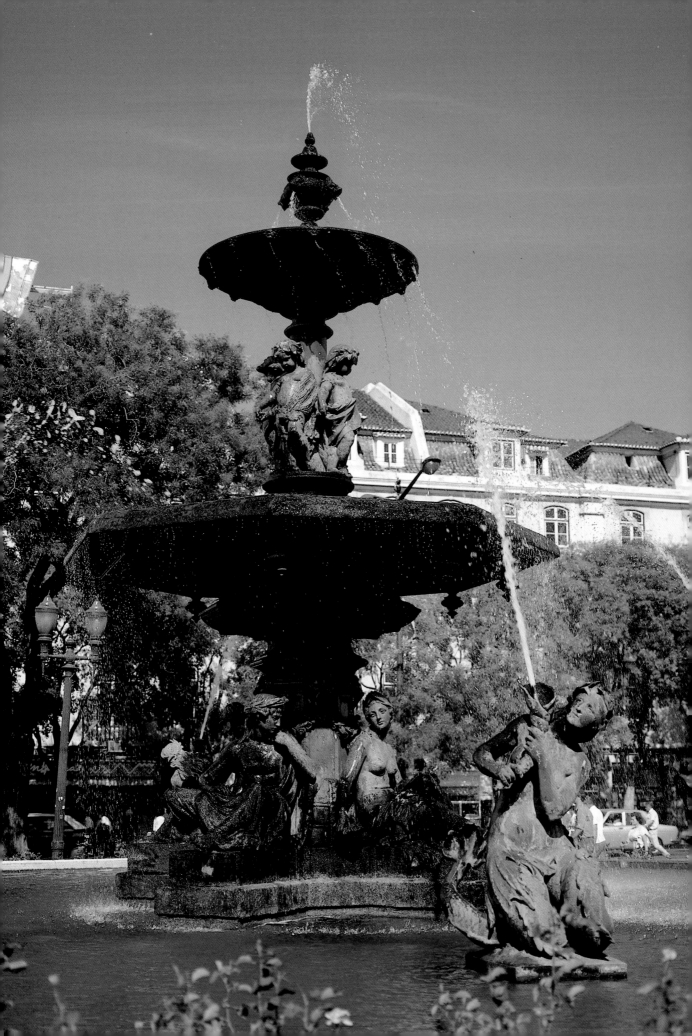

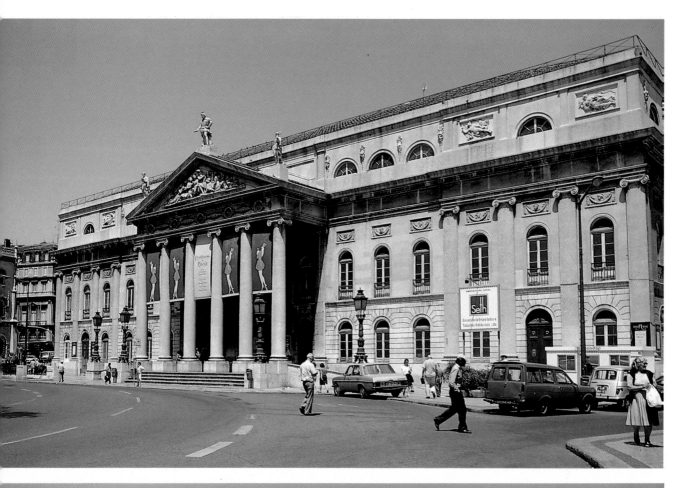

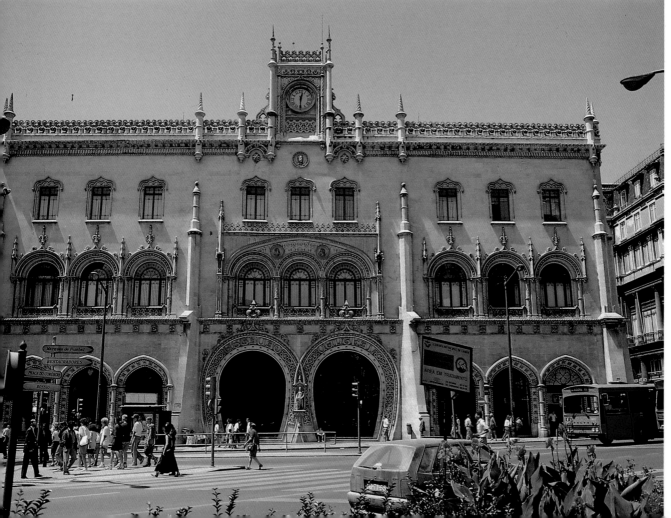

PRAÇA DA FIGUERA

On the east side of Rossio, **Praça D. João I**, simply known as **Figueira**, is a wide and beautifully paved square with black and white pavements, and surrounded by shops.

In 1883, the design of the market in Praça da Figueira was approved as part of the plan for the reconstruction of the city. The market became a major centre for shopping and entertainment. Demolished in 1949, amid loud protests, the space was left with only the equestrian statue of João I in the centre. Designed by Leopoldo de Almeida, the statue was placed in the square on the Jorge Segurado pedestal in the 1970s.

Near the square are the **Church of São Domingos** and the Palace of the Counts of Almada, or **Palace of Independence**, renowned for having been the site of the conspiracy which came to a head on 1 December 1640, with the restoration of Portuguese Independence. In one of the rooms, the Pavilion of the Conspirators, there are *azulejos,* or ceramic tiles which commemorate the event.

D. Maria II National Theatre (1842). Busts of famous Portuguese poets have been incorporated above the windows of the middle floor.

The XIX c. Rossio Station in neo-Manueline style.

Statue of D. João I on Praça da Figueira.

Praça da Figueira and St. George's Castle in the background.

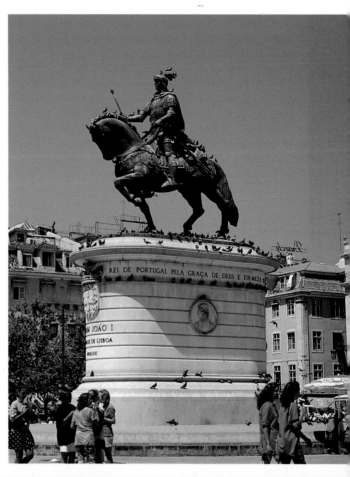

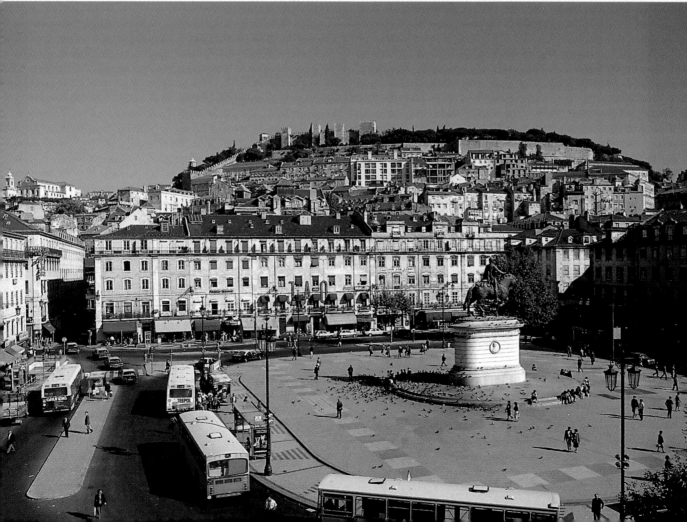

BAIXA

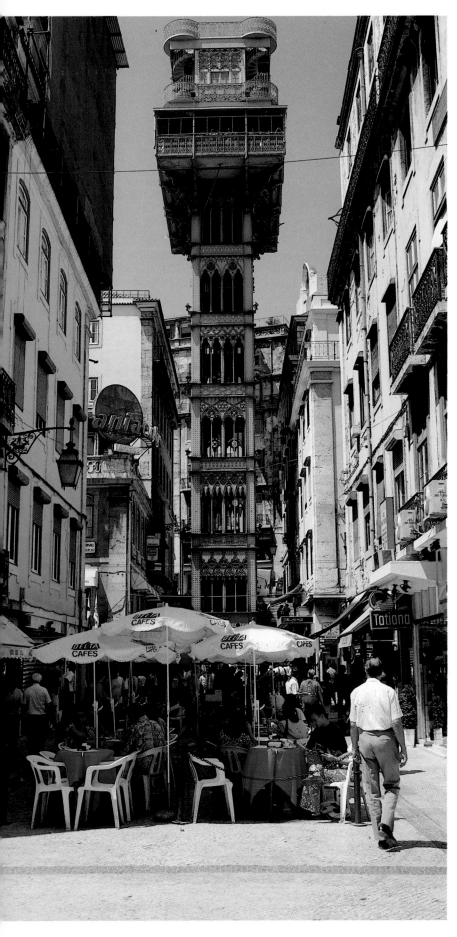

Baixa - downtown - is the name given to the flat rectangular area which extends from Rossio down to the river. The streets, which cross at right angles, are full of offices, banks, shops and cafés.

The sober and uniform architecture is a result of the economic austerity which marked the reconstruction of Lisbon after the earthquake. The Marquês de Pombal, in cold and forward-looking style, ordered that the living be taken care of, that the dead be buried and the city be reconstructed. This meant an end to the tangled web of narrow and crooked little streets which can still be found in other areas of the city where the earthquake, tidal wave and fires did not wreak so much damage.

The Baixa was thus designed to a geometrical plan, with streets considered wide for the time, lined with buildings whose structures were thought until recently to be designed to withstand earthquakes, but which are in fact designed to resist fire. The monotony is broken by wrought iron balconies, the wide windows and the red tile roofs leaning over the pavement mosaics, first laid in the early nineteenth century.

As can be seen from the street names, nothing escaped the spirit of organisation. Trades were grouped together, and the most prestigious were located in the most important streets. Today, you can still find the majority of goldsmiths and silversmiths situated in Rua do Ouro and Rua da Prata (Gold Street and Silver Street). In Rua do Ouro is also one of Lisbon's several elevators - the **Santa Justa**, designed by Raoul Mesnier de Ponsard. The more modest traders, such as dry goods merchants, saddlers, gilders and haberdashers, continue to proliferate in the other streets. Some streets have an almost provincial air about them, while in others are found old fashioned "tascas", or taverns. A good example of this is the Rua dos Sapateiros - Shoemaker St. - starting at the Bandeira Arch, where the **Animatógrafo** is located - the only Art Nouveau cinema in Lisbon.

Elevador de Santa Justa (1901) connecting the Baixa quarter with the Bairro Alto.

From the upper platform of the Elevador de Santa Justa there is a good view of the Rossio and the Baixa.

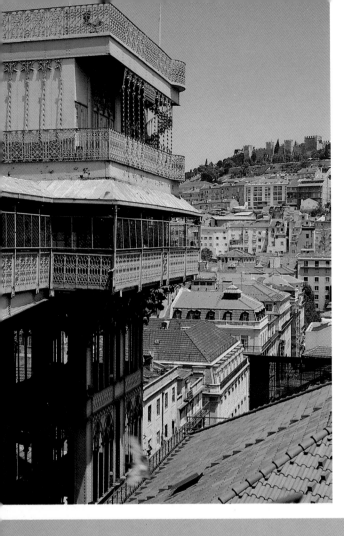
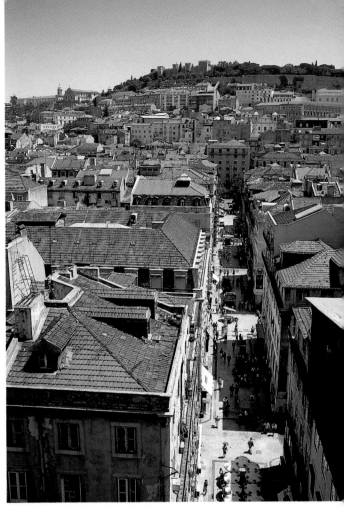
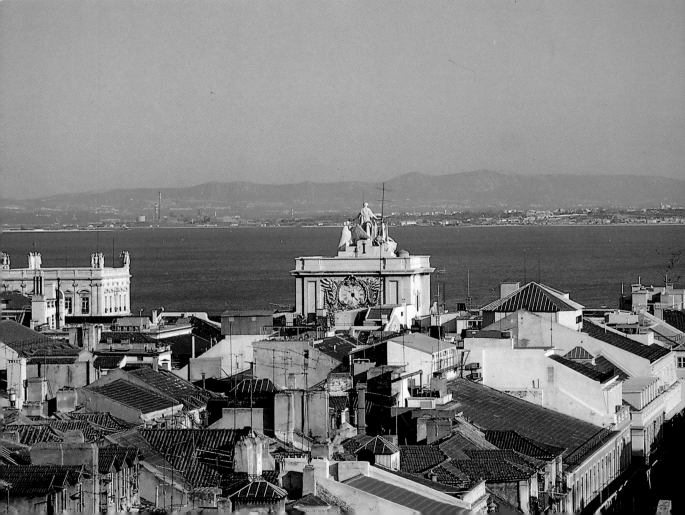

PRAÇA DO COMÉRCIO

Right on the Tagus banks, giving onto the **Cais das Colunas**, the **Praça do Comércio** was also born out of the debris of the earthquake. It was given its present name at the time of reconstruction, but people still call it **Terreiro do Paço** - Palace Square, its name before the earthquake, when the Ribeira Palace was still standing. The palace was built in the sixteenth century by Manuel I. It contained many works of art and boasted one of the largest libraries in Europe.

Today, a number of ministries are housed in the existing seventeenth century buildings. The centre of the square is dominated by the capital's first **equestrian statue**. The work is by the sculptor Machado de Castro, and represents José I, a King who would not really have left his mark on history but for the enormous strength of his Prime Minister, the Marquês de Pombal. The statue was unveiled with great pomp and ceremony twenty years after the earthquake. The artist, however, was not present, having been forcibly removed from the proceedings.

The Praça do Comércio is the most beautiful square in Lisbon and one of the most memorable in Europe. Leading off it are several streets, most notably the Rua Augusta, starting with a triumphal arch which took 118 years to complete. The arch was designed by the architect Veríssimo José da Costa, and is flanked by two figures representing the rivers Tagus and Douro, left and right respectively. There are also four statues by Vítor Bastos, portraying great names in Portuguese history. On the left, Nuno Álvares Pereira, constable to the monarchy in the fourteenth century, a leading strategist in the battles against the attacks of the Castillian King. Next to him, Vasco da Gama, discoverer of the sea-route to India in 1498. On the right, the Marquês de Pombal and Viriato. The latter is considered to be the first national hero for having been the military chief of the Lusitanian resistance to the Roman invasions in the second century B.C. A group of allegorical figures by the Frenchman Anatole Calmels, symbolising Glory crowning Genius and Valour, completes the monument.

On the corner with Rua da Prata, the **Martinho da Arcada Café**, the oldest in Lisbon, is one of the capital's most famous meeting places, thanks to the history it shares with Fernando Pessoa. Like many other poets and writers, especially during the 1920s, he used to frequent the café, often to write. In spite of the constant noise of traffic, many people enjoy sitting at the tables outside, savouring the welcome cool breezes in the

Arco Triunfal and King José I Memorial.

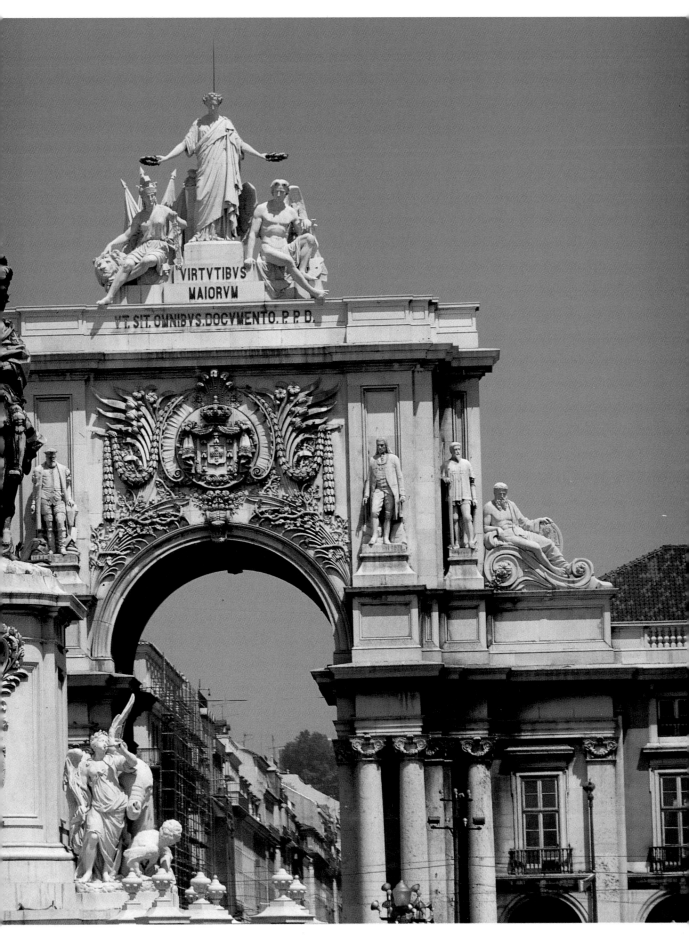

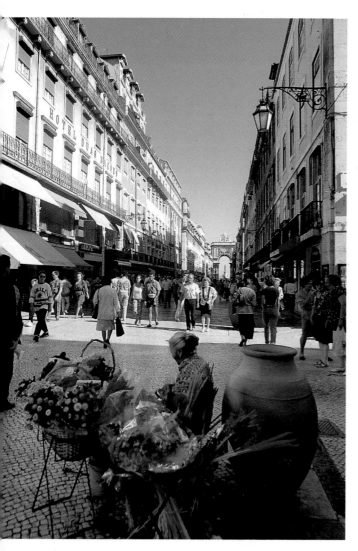

Rua Augusta, a fashionable shopping street.

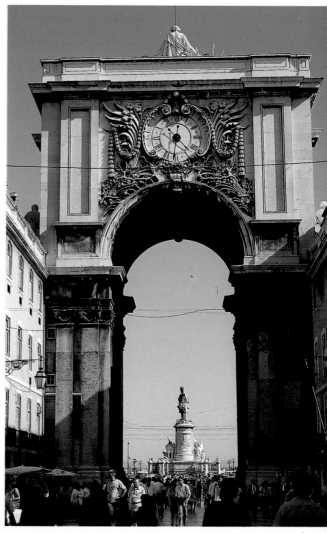

The XIX c. Triumphal Arch leads to Rua Augusta.

The statue of King José I was erected on Praça do Comércio in 1755.

middle of summer. The interior is just as comfortable and inviting, and still retains the recently restored décor of times gone by.

Terreiro do Paço is a place where great events have been taking place since the sixteenth century. It has seen the arrival and departure of the famous, the executions of those fallen from grace, the autos-da-fé of the Inquisition, pageants, processions, parades, courtly and popular festivities, including very special moments, such as the assassination of King Carlos and the heir to the throne, Luís Filipe, on 1 February 1908, the vehement call by the dictator Salazar for troops to go to Angola "in force" in 1960, and the large demonstrations during the stormy months following the revolution of 25 April 1974.

Despite the constant traffic, the Praça do Comércio offers a good view over the river. Boats of all sizes ply the waters, especially the two-tone ferries which leave the various river stations to cross the Tagus to Montijo, Seixal, Barreiro and Cacilhas.

On Sunday mornings, under the arcades, there is a collectors' fair. The Municipal Council is committed to reclaiming the square for the people and has organised concerts and festivities, especially on New Year's Eve. Events such as these renew the ancient relationship between the city's inhabitants and the river. In summer especially, in the shimmering light of Lisbon, with the Tagus almost lapping at your feet and a view that goes on for miles, not even the noise of the traffic keeps away the thirsty.

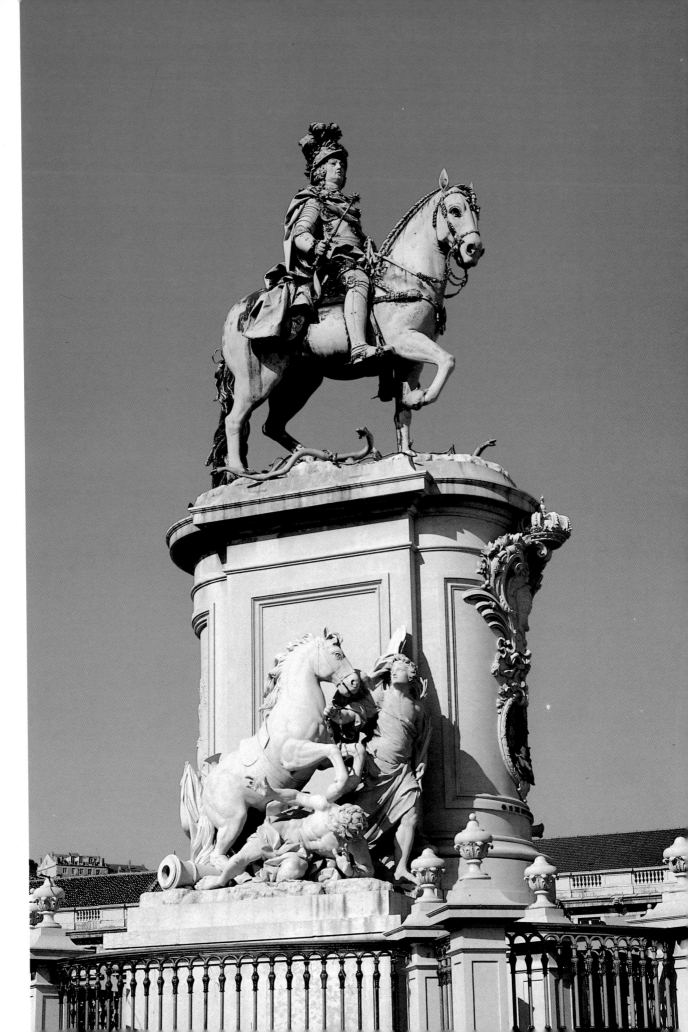

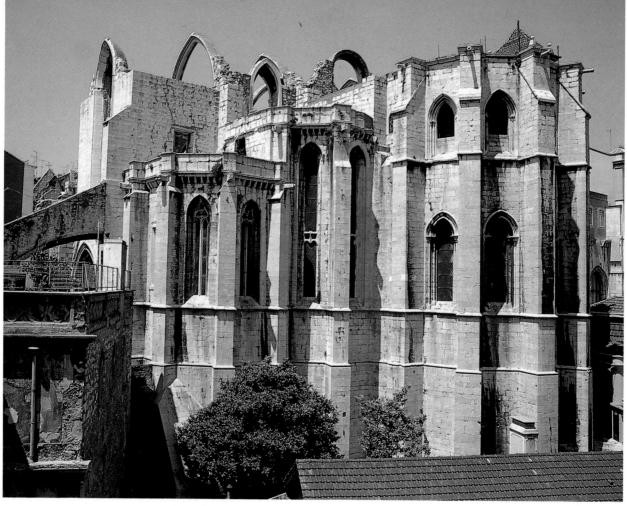

The Carmo Church (XIV c.) was destroyed by the earthquake in 1755. A view of the eastern section of the chancel.

The fountain in the middle of the Largo do Carmo was built in 1796, opposite the Gothic church portal.

Summer concerts often take place in the church ruins.

RUÍNAS DO CARMO

After a ride up in the **Santa Justa Elevator**, you come out at **Largo do Carmo**. After the stunning view from the upper platform of the lift, the square seems modest in comparison. However, entering the **Church of Carmo** is like stepping back in time. What remains of the building resembles a skeleton left to dry in the sun, because of the brilliant white of the ruined stone arches. The ruins have been left like this on purpose, as a reminder of the earthquake of 1 November 1755. At one time it was the richest and most venerated church in Lisbon. Visible from various parts of the city, like a harmless ghost from the past, it is a good place to hear music at the concerts occasionally held there on summer evenings.

The church and monastery were built around the end of the fourteenth century in fulfilment of a vow made by Nuno Álvares Pereira, comrade in arms of King Joaõ I, during the battle of Aljubarrota. He vowed to the Virgin Mary that if they won he would build the most beautiful shrine in the country. He kept his vow. The church was designed by Gomes Martins, and built in the Gothic style. It was magnificent and the contents were as

impressive as the church itself. Its statues were lit by the colourful light coming through the stained glass windows, and it guarded treasures and relics, most of which the earthquake later swallowed up.

After having performed his vow, the Holy Constable, as his title was, gave away his earthly belongings and entered the monastery (under the name of Brother Nuno de Santa Maria) in 1423 when building was finished. He died six years later. For many years, people used to make pilgrimages to the church. They would dance and sing around the grave of the hero of Valverde and Aljubarrota.

Some conservation work last century was carried out to keep the ruins standing. Since that time, the *Association of Portuguese Archaeologists* has been based here, as well as a small, but important museum which houses mainly sculpture, engravings, tombstones and coats of arms collected from the city.

Despite the graves and the bare stone, there is nothing sinister about the church. Grass and flowers grow between the tombstones and the blue skies set off the

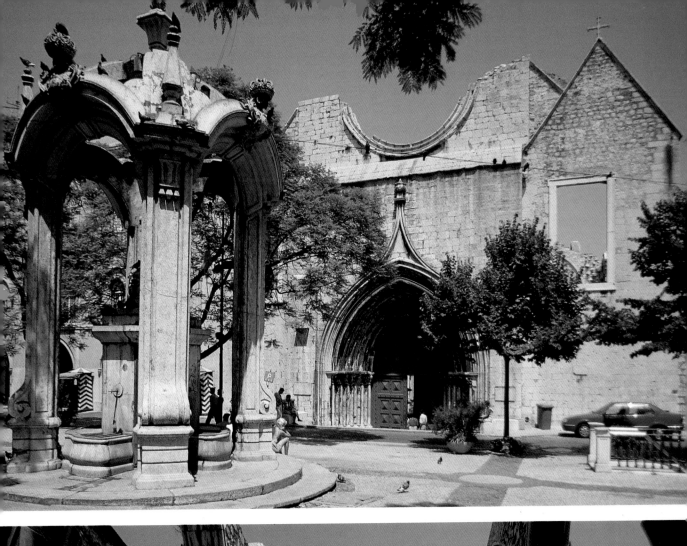
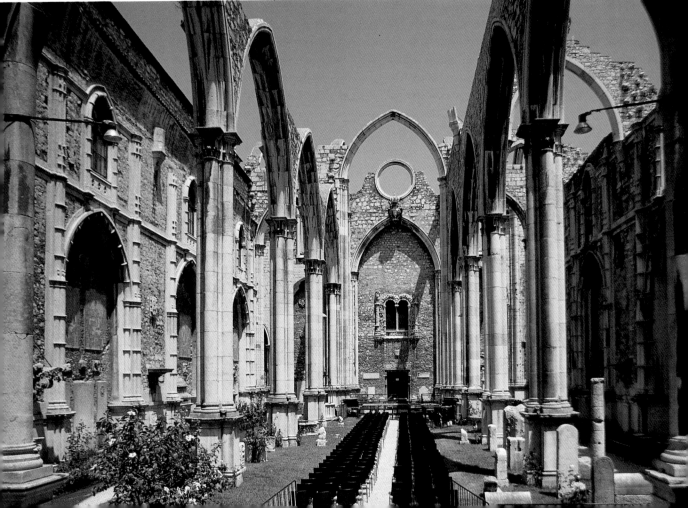

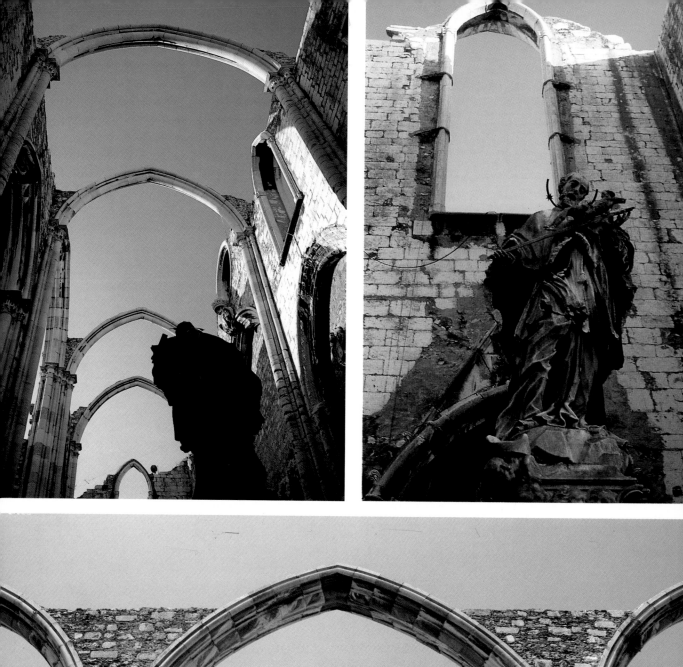
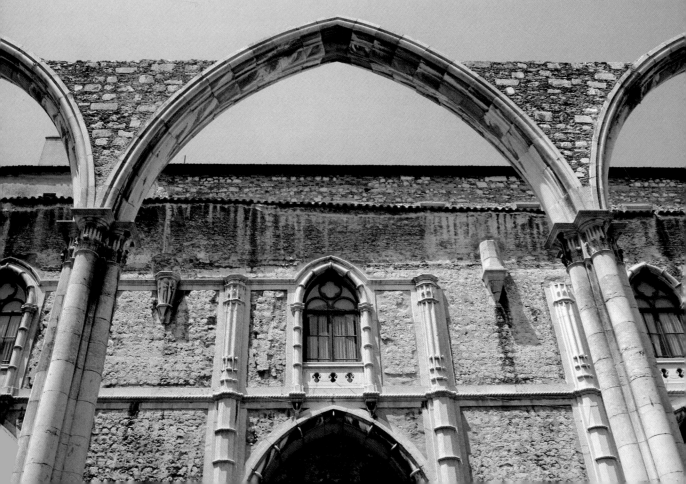

surroundings. It is in fact possible to see right through the pointed arches, so it comes as no surprise to see flocks of pigeons or swallows flying around their nests.

The square itself is full of cars and children playing. The fountain standing in the middle of the square was built in 1796, and features a domed roof resting on four columns.

The square played an important part in the political history of the last 20 years and is closely associated with the *1974 Carnation Revolution*. The monastery, used as the barracks of the present *Guarda Nacional Republicana - G.N.R.* (police) since 1836, was the chosen refuge of the former Prime Minister on 25 April 1974, whilst outside, people filled the streets showing their support for the Armed Forces Movement. Much time has passed since then; the young people who cross the square today are heading for the fashionable nightlife of the **Chiado** and the **Bairro Alto**.

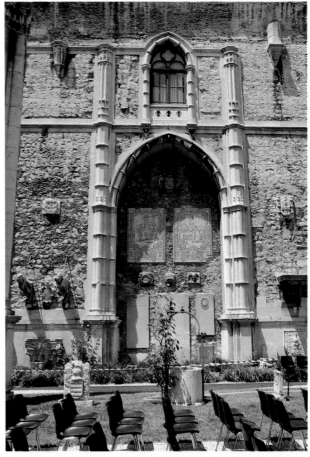

The ruins are one of the relics of mediaeval Lisbon built in the almost pure Gothic style.

St. John Nepomucenus (1743) on the right side of the transept.

Scenes of the Passion depicted on two tile panels (XVIII c.) on the left aisle.

The tomb of D. Fernando I (1376) in the roofed section of the chancel.

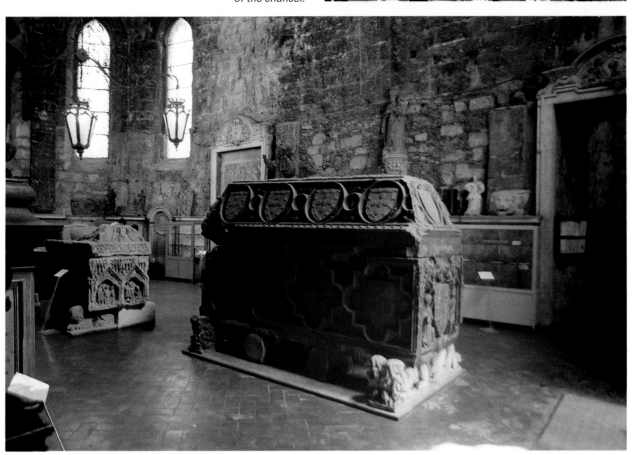

THE CHIADO

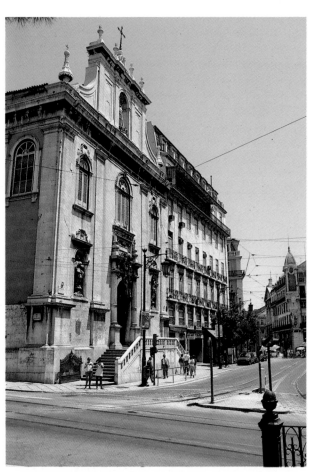

Largo do Chiado, home to the Lisbon *beau monde*, has featured in the pages of the most illustrious writers since the last century. Their characters have all strolled down Rua Garrett, Rua do Carmo and Rua Nova do Almada. The elegant, traditional shops and the cafés where literary figures met in the past are the main attractions.

Chiado also boasts famous neighbours. Nearby, the **Largo das Duas Igrejas** where the two churches stand opposite each other. The **Church of Nossa Senhora do Loreto**, which ministered to the Italian community, was designed by Filippo Terzi. In spite of the fire in 1651 and damage inflicted by the earthquake, the church maintains its original Mannerist style. Its facade is austere, yet elegant, featuring a group of marble angels by Borromini. Its interior displays works by the Italian school. It also features a ceiling painted by Pedro Alexandrino and paintings by Wolkmar Machado.

The single nave Igreja do Loreto, built in 1518, and its remarkable double flight of entrance steps.

The memorial (1867) to Portugal's greatest literary figure, Luis de Camões, stands on the square named after the poet.

Bronze memorial of Fernando Pessoa (1888-1935) outside A Brasileira (1922) on Largo do Chiado.

Bronze statue of António Ribeiro (1520-91) the playwright who apparently gave Chiado its name.

Largo de Chiado, where originally was located a XIV c. city gate, looking West towards Largo de Camões.

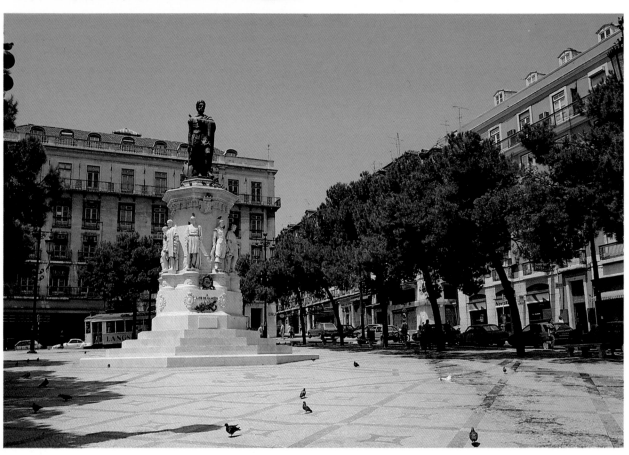

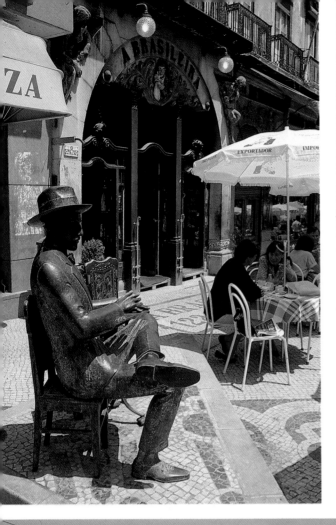

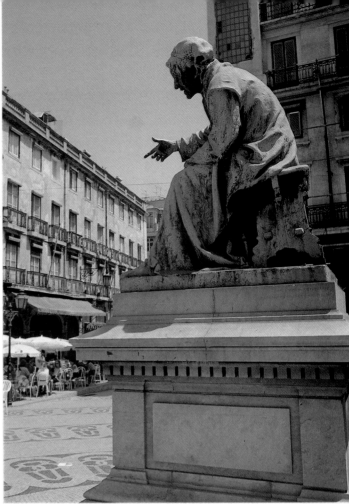

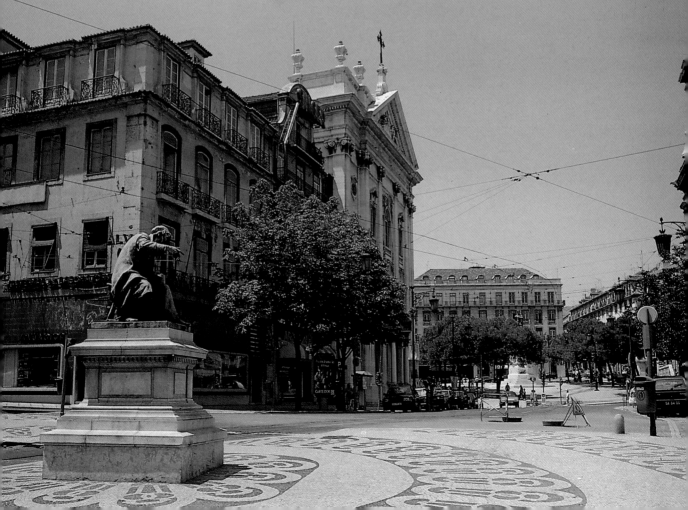

The **Igreja da Encarnação** was finished in 1708, destroyed in 1755 and restored years later by Manuel Caetano de Sousa. The church looks equally sober from the outside, although it also houses paintings by Wolkmar Machado, Manuel da Costa and G. M. Appianni amongst others. Slightly further up Chiado is **Largo de Camões**. The square, inhabited by sparrows and pigeons surrounds the nineteenth-century statue of Portugal's greatest poet.

A little way down in the opposite direction is a third church, the **Igreja dos Mártires** dating from the end of the eighteenth century. All round it are antiquarian book sellers and theatres - the select **São Carlos**, the **Municipal São Luís** and the **Trindade**. Years ago, there was also the ill-fated *Gimnásio Theatre*, now converted into a shopping centre. In the same street is the famous **Trindade restaurant** decorated with interesting *azulejos*, and housed in the old refectory of the Trindade monastery.

In the Largo do Chiado itself stands the statue of the poet and dramatist António R. Chiado, a contemporary of Camões.

The most famous café in Lisbon - the **Brasileira** - still holds its own against the advance of the many banks and other businesses which are increasingly taking up residence in the Chiado. People on their way out for the evening still meet up there before heading for restaurants, theatres, bars and discos. **Fernando Pessoa**, or at least a bronze statue of him, sits outside the café which is now the centre of elegance that the Chiado ceased to be even long before it was mutilated by fire in August 1988.

Azulejo panels depicting Masonic symbology on a XIX c. building at Rua da Trindade.

Tile panel outside an antiquarian bookshop at Chiado.

SÃO ROQUE

The **Church of São Roque** was built at the end of the sixteenth century. It was designed by the Italian Filippo Terzi along with Afonso and Bartolomeu Álvares and stands on the former site of a small hermitage.

The modest architecture of the new church, which belonged to the Jesuits, clearly demonstrates the austerity imposed at the time by the canons of reform. It has a single nave, giving onto eight side chapels, including the beautiful and precious Chapel of St. John the Baptist, commissioned from Rome by João V.

The decoration, gradually added later, is luxurious. There are excellent marbles by Francisco de Matos, examples of Mannerist and Baroque gilded woodwork, and *azulejos* from the sixteenth and seventeenth centuries, as well as ceiling paintings completed in 1588.

There is also a small museum which contains the precious treasures and vestments from the Chapel of St. John the Baptist, the portraits of João III and Queen Catarina, attributed to Gregório Lopes. The museum also houses the *Book of Rules of the Misericórdia* and the painting which tells the story of the wedding of King Manuel and Queen Leonor, as well as other important works.

The late XVI c. Igreja de São Roque at Largo Trindade Coelho whose façade was rebuilt after the earthquake of 1755.

The richly decorated chapels of N.S. da Piedade and N.S. da Doutrina.

Following page: a view of the Baixa and St. George's Castle from the Belvedere at São Pedro de Alcântara.

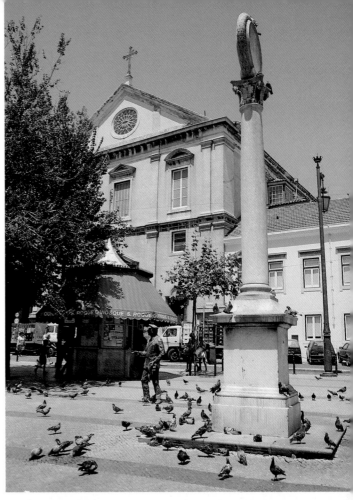

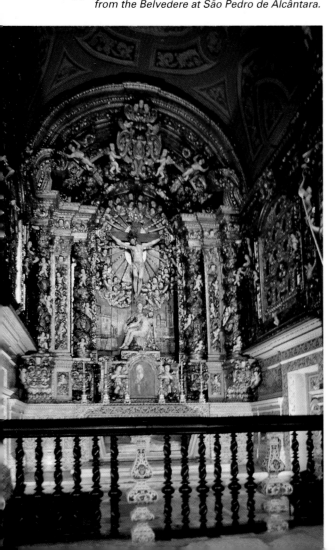

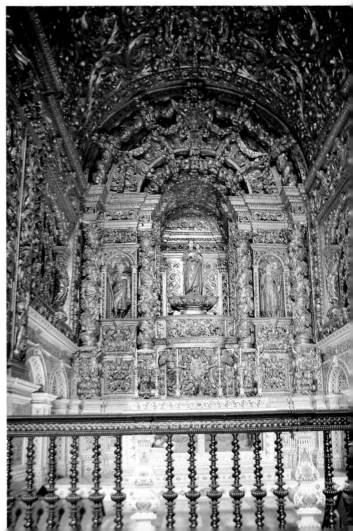

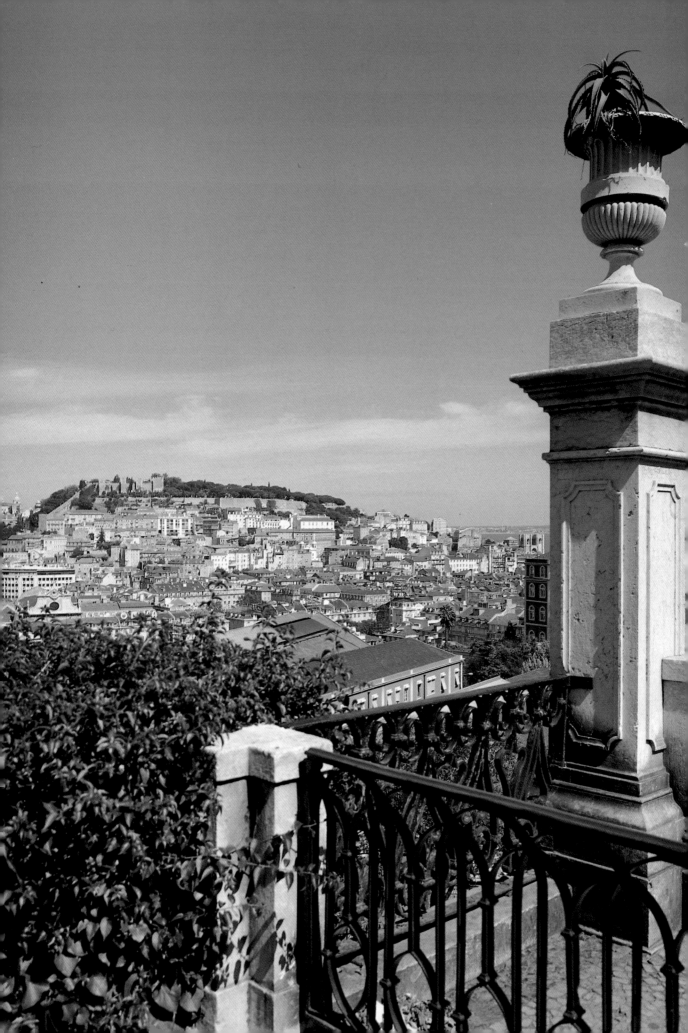

SÃO PEDRO DE ALCÂNTARA
ELEVADOR DA GLÓRIA

Leading off from **Praça dos Restauradores**, is an extremely steep hill climbed by one of Lisbon's most typical forms of transport - the **Elevador da Glória** - the Gloria Funicular. Various parts of Lisbon are served by this system and also by trams which climb the city's steepest slopes. Valleys appear at each step, as well as incredible views from the hills, not always easy to climb up. Gliding up between the walls of the nearby houses, the Glória Funicular takes you smoothly past the small **Largo da Oliveirinha.**

Opposite is the **Port Wine Institute**, housed in a palace dating from 1747. There you can enjoy a glass of port from the banks of the Douro.

With your back to the **Bairro Alto** - literally the Upper Quarter - and halfway between the squares of Carmo and **Príncipe Real**, the view from **São Pedro de Alcântara** is like an open window over the city.

In the foreground, beyond the open garden directly below, lies Avenida da Liberdade, and the rooftops of the Baixa. On the right of the scene is the cathedral, with its stone almost white against the Tagus. On the hill opposite, standing proudly over the surrounding districts, is **St. George's Castle**, whose walls enclose an island of green.

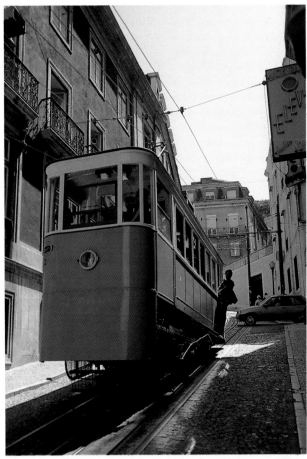

Elevador da Glória (1885) one of the three funicular railway which links Bairro Alto with Avenida da Liberdade.

The São Pedro de Alcântara belvedere.

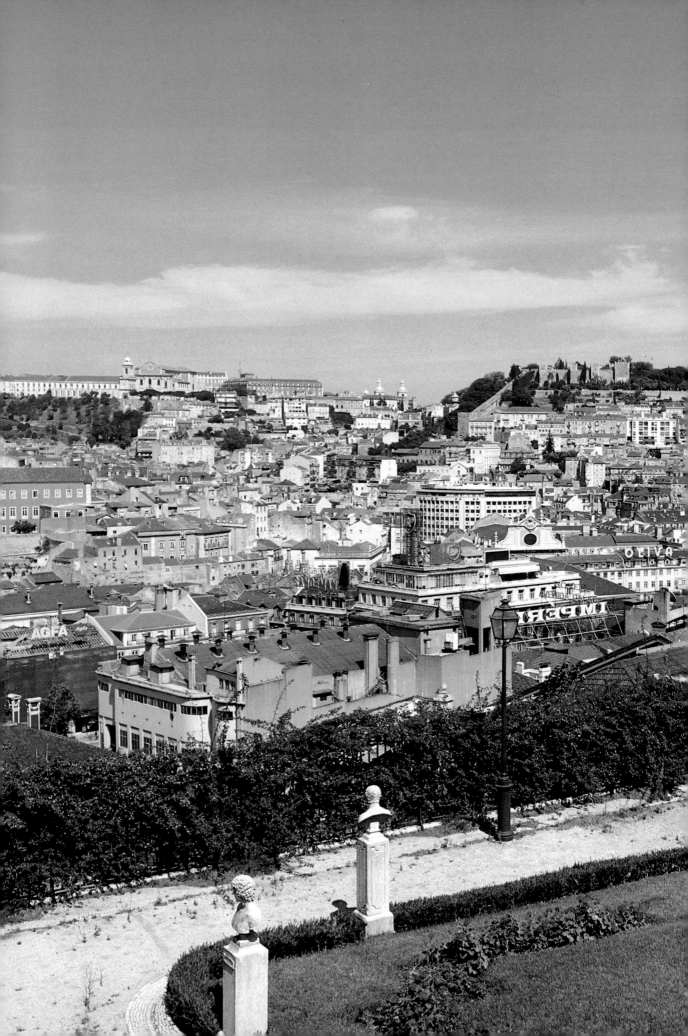

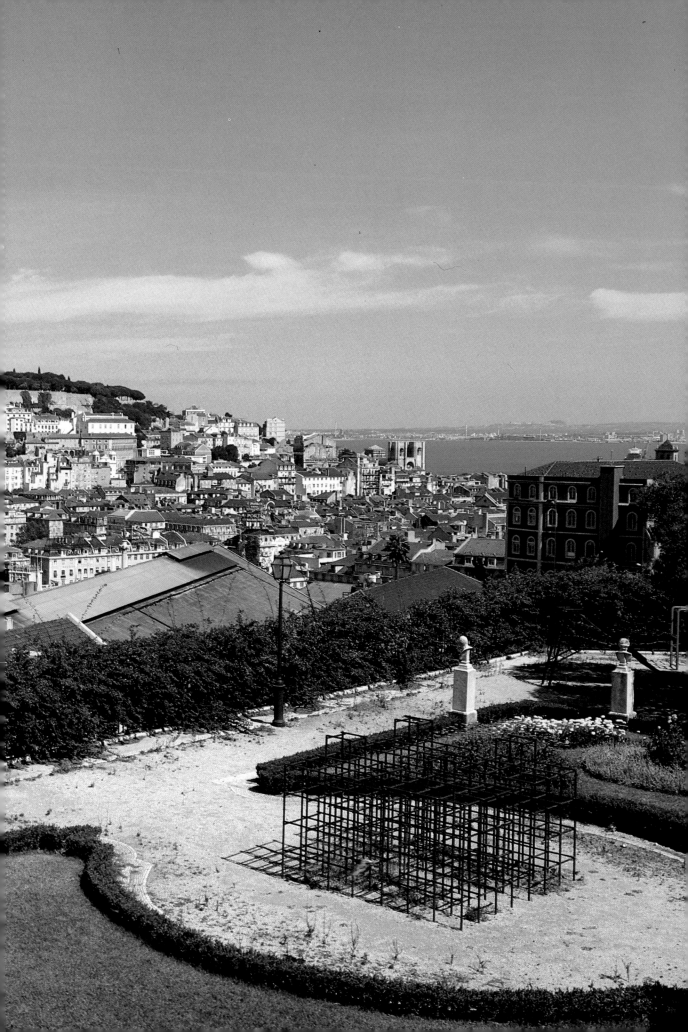

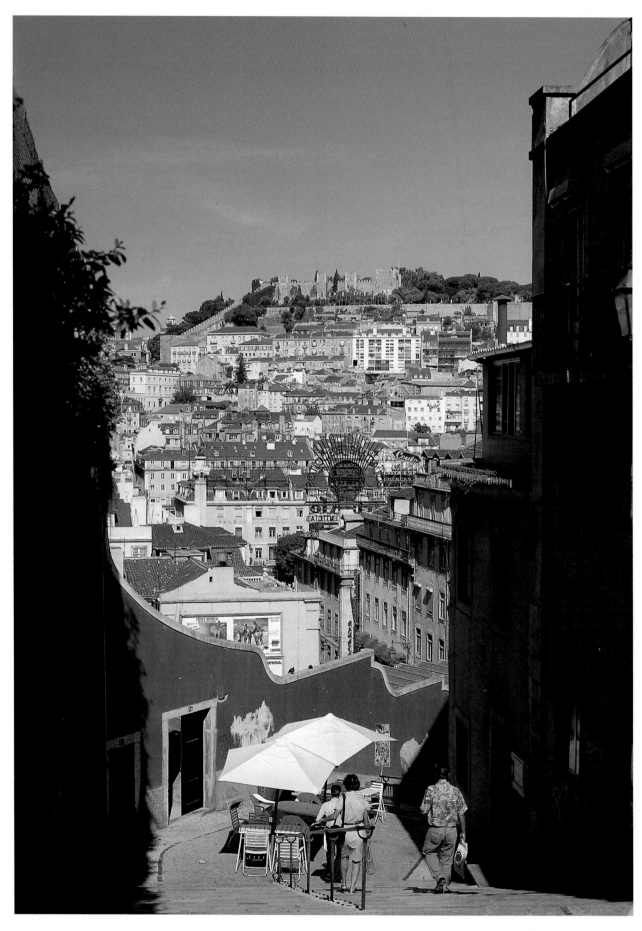

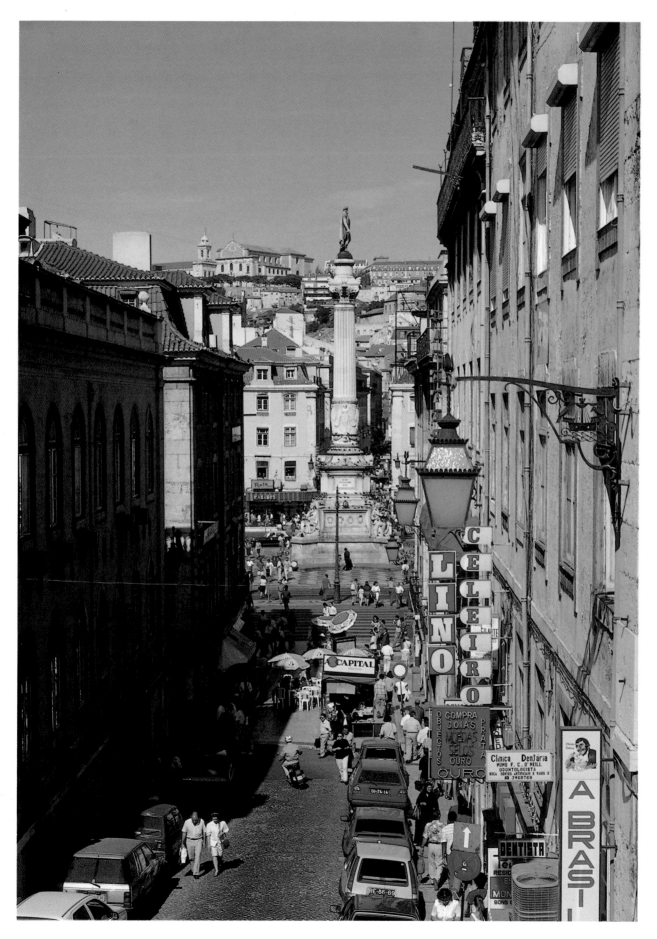

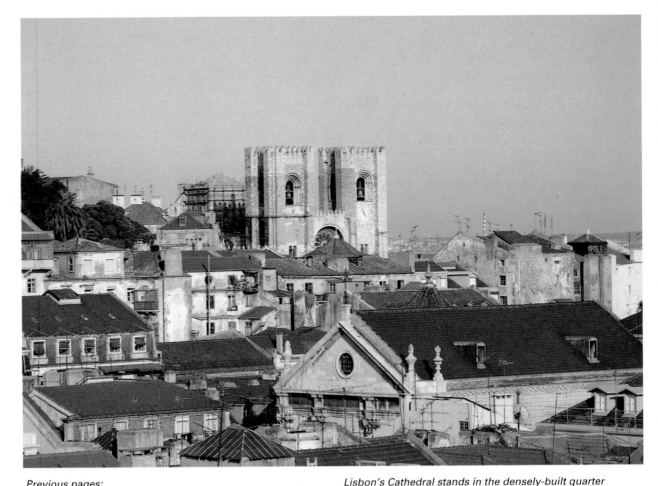

Previous pages:
p. 28-29, panoramic view of downtown Lisbon from the belvedere of São Pedro de Alcântara;
p. 30, a view of the Castelo de São Jorge from the upper limit of Calçada do Duque;
p. 31, Calçada do Carmo leads onto Rossio Square where the 1870 marble pillar topped with the statue of King Pedro IV is found.

Lisbon's Cathedral stands in the densely-built quarter south of the Castle hillside.

Sé Patriarcal, a fortress-like temple built in the Romanesque style by order of King Afonso Henriques in 1147.

SÉ - CATHEDRAL

Past the Church of Santo António, climbing further into the Alfama along the tram lines, a fortress-like building with two massive and symmetrical towers dominates the ascent. Its enormous doorway is topped by a large rose window, in an easily discernible Romanesque style. Visible from nearly everywhere in the old city, its battlements jutting up into the sky, this is the **Sé** - or Cathedral.

A walk around the building reveals the richness in Gothic detail, in the lancet windows and the pale yellow stone carved arches. The cathedral's imposing facade, with its galilee and recessed portal with four archivolts, stands out amidst the sobriety of the neighbourhood. It forms a wedge between two streets halfway up the hill. It seems to have always been there - but it is still easy to forget that its first stone dates at least from the time when the Christians took the city.

In 1147, in fact after the victory over the Moors in which he retook Lisbon, King Afonso Henriques decided to purify the city and build a Catholic church. The site chosen for the church of Santa Maria probably contained the ruins of a mosque, a theory which current excavations tend to confirm. There are also those who think that before the Muslim shrine a Christian Church may have existed there. Whatever the case, everything indicates that the building work had been started immediately, hence its robust Romanesque style more like a fortress than a church. This is still evident today, despite repairs and changes down the ages.

Although an unremarkable monument, the Sé has survived through the ages and is steeped in history. It has been the scene of many events and a victim to the earthquakes which have rocked the city for centuries. During the crisis of 1383-85, the populace mistrustful of the Bishop who was accused of siding with the Castilians, decided to put an end to their doubts once and for all and threw him out of the window of the northern tower. There below, according to Fernão Lopes, a chronicler of the time, wild dogs devoured his body.

The cathedral was built in a series of different styles, one after the other, not all of them successful. **Gothic cloisters** were added to the original twelfth-century building

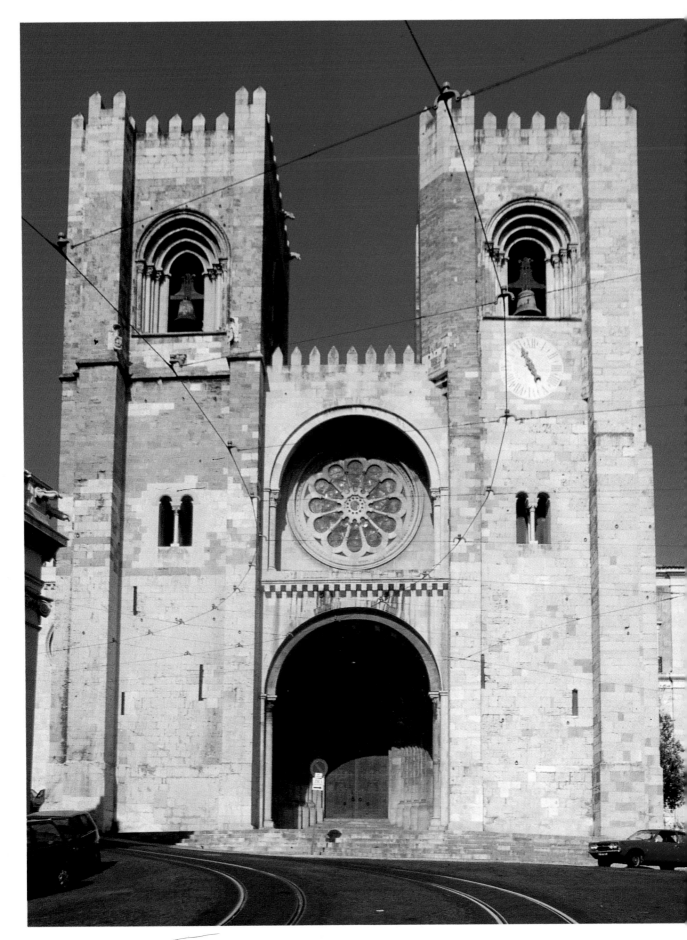

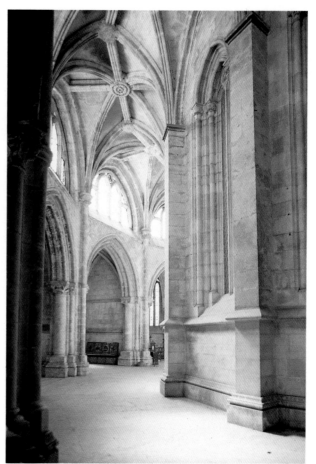

Sé Patriarcal, the south tower.

Ambulatory with radiating chapels.

The notable tombs (XIV c.) of Maria Vilalobos and her husband Lopo Fernandes Pacheco an officer and friend of King Afonso IV.

during the reign of King Dinis, at the end of the thirteenth century. Mid-fourteenth century, the ambulatory and the **Gothic chapels** of the chevet were built. There have also been changes inside the cathedral, with the Romanesque chancel being rebuilt in Gothic style.

The 1755 earthquake destroyed the belltower over the crossing and also caused much damage to the southern tower. Restoration, which only started in 1777, unfortu-

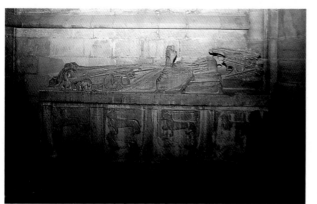

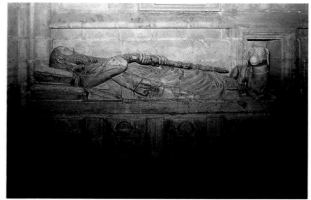

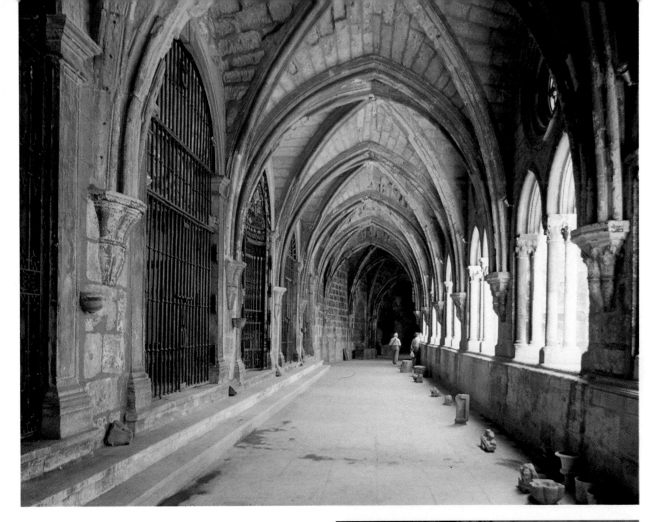

North gallery of cloister with quadripartite vaulting.

The tomb of D. Margarida Albernoz in the Chapel of the Misericord.

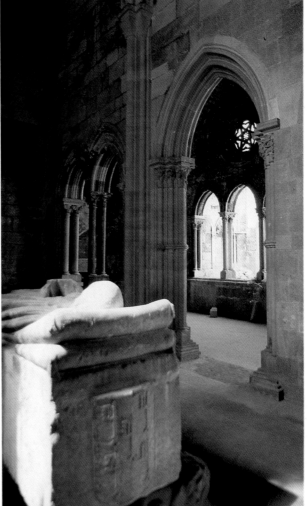

nately disfigured the cathedral despite rebuilding the southern tower and the vault. Stucco and other fashionable decoration was added inside, robbing the building of its solemnity. Work at the end of the nineteenth century restored its medieval design, and its dignity.

In the entrance of the church today are two tombstones, the one on the left has Gothic-monastic characters, the other has an epitaph in Latin. Both commemorate the conquest of the city by the Christians. **Inside**, the nave and two aisles rise to the roof, a central barrel vault flanked by groin vaulting over the aisles. The ambulatory and chapels are among the best examples of the Gothic style in Portugal. In these chapels there are medieval tombs, such as that of the Unknown Princess in the fourth chapel, and those in carved stone, with the statues and coats of arms of Dom Lopo Fernandes Pacheco, favourite of Afonso IV, and his wife Dona Maria Vilalobos, who lie at rest in the seventh chapel. A valuable eighteenth-century organ stands on the right, in the chancel. Whenever it is played in the afternoon or evening concerts, the whole church resounds with almost a magical quality.

The passing of time is clearly visible in the chancel. The

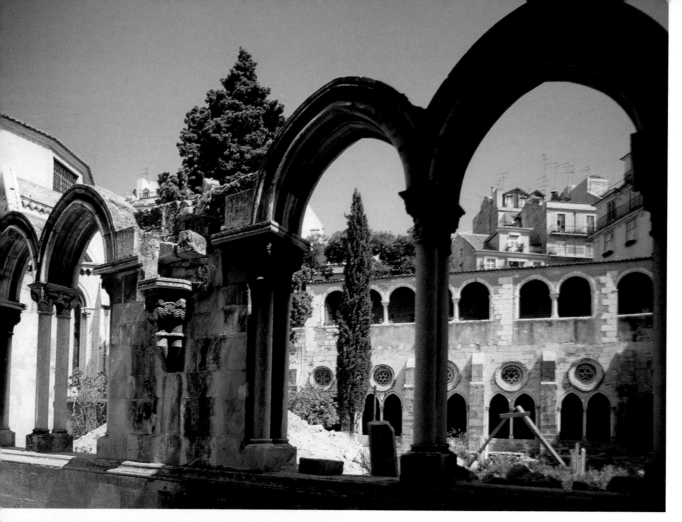

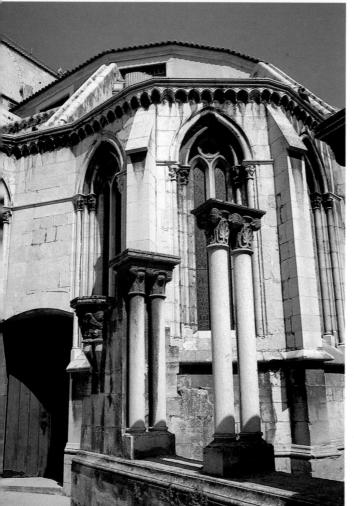

tombs of Afonso IV and Dona Brites are modern, as the medieval tombs were lost in 1755. From the initial Romanesque to the Gothic style, which made the cathedral higher, the walls have also been decorated with wood carvings dating from the mid seventeenth century. There are also Baroque influences, although they are not the best examples of the style.

Despite excavation work currently underway in order to discover more about the history of Lisbon, the little known cloisters of the Sé have a quiet restful beauty. Located on the Eastern side of the building, they reflect the Gothic style of the late thirteenth century. The rib vaulting and other inventive original details resemble the Cloister of Silence at Alcobaça Monastery. The silence here is also striking. It seems to fill the air between the arches built in the time of King Dinis, the Poet King. The sacristy, a north facing addition dating from the seventeenth and eighteenth centuries, guards the presumed remains of St. Vincent. One of the Sé's more agreeable surprises is the treasury, which is however not always open.

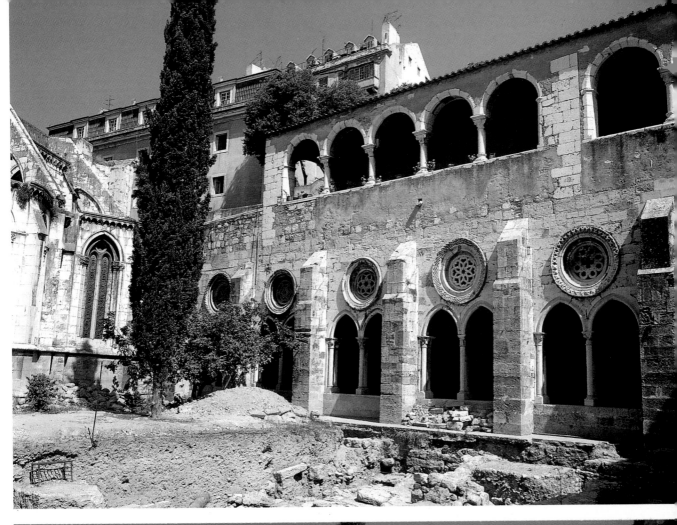
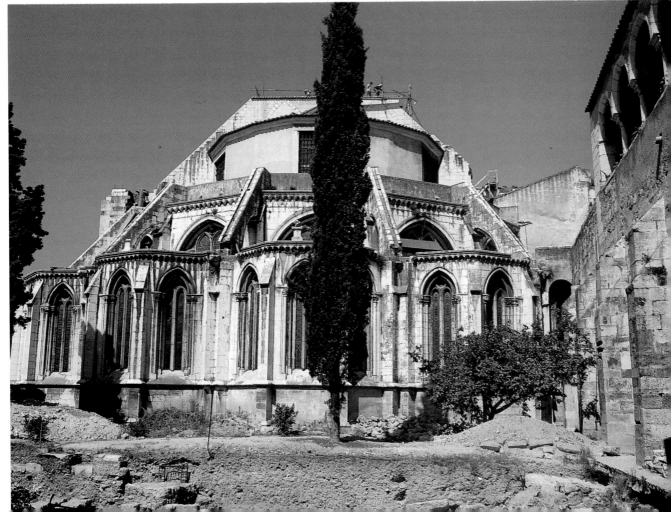

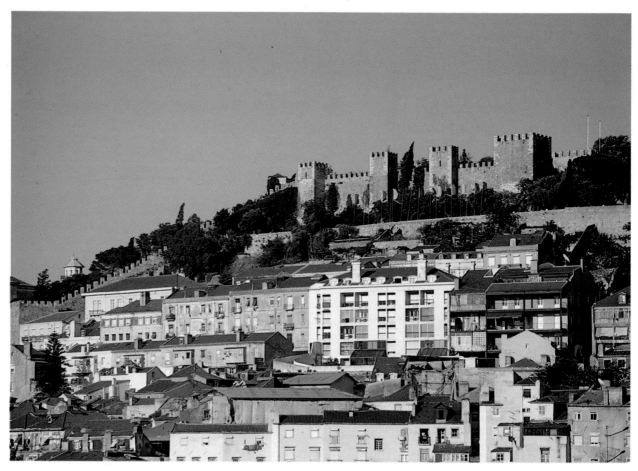

The Castelo de São Jorge (V c.) stands on a hill 110 m above the Baixa quarter.

Partial view of the city from the belvedere at the Terrace.

CASTELO DE SÃO JORGE

The **Castelo de S. Jorge** is situated at the top of a hill in a strong strategic position. The castle was given its name by João I, in honour of his English wife. It was the city's first defensive construction, and its history dates back to before the Romans. After the Romans, the Visigoths lived there, followed by the Muslims. They extended the section of wall still known today as the Moorish wall or Old Wall of Lisbon, to tell it apart from the wall built by King Fernando. Conquered by the Christians in the twelfth century, it underwent several changes throughout the next few centuries. However, its general look is still medieval.

The castle is divided into three parts: the **Castelejo**, or Old Castle, the **Citadel** and the **Alcáçova Palace**, home of the Portuguese monarchy until King Manuel. It was here in 1502, during the celebrations after the birth of the future king João III, that Gil Vicente presented his *Cowhand's Monologue*, taken to be the beginning of Portuguese theatre.

Walking along the ramparts, it is possible to see almost all of Lisbon. The view stretches from the roofs of the Baixa, along to Graça, Alfama, Mouraria, Bairro Alto, and even northwards to the "New Avenues" - the area around Avenida da República. The whole scene is punctuated now and then by Lisbon's many monuments; from the Sé to Estrela Basilica and up to the Carmo ruins. Over the other side of the river, following the so called **Mar da Palha**, the view extends further south. On clear days, you can even see the Arrábida hills, a natural reserve rich in wildlife.

Returning to the castle walls, there are two statues which deserve special mention: one, of Afonso Henriques, the first King of Portugal, stands in *Praça d'Armas*. The other, on the north side is of Martim Moniz, the nobleman who let himself be jammed between the city gates, giving his own life so that the Christian troops could gain entry.

Further down, the story continues. After their defeat, the Moors were given permission to stay in Lisbon. They then settled in the shady north side of the city, in the district which came to be called Mouraria. Years later, this district of ill repute, inhabited by Jews, won a special place in the heart of the city. It was in its narrow alleyways that the mythical Fado singer Severa was born,

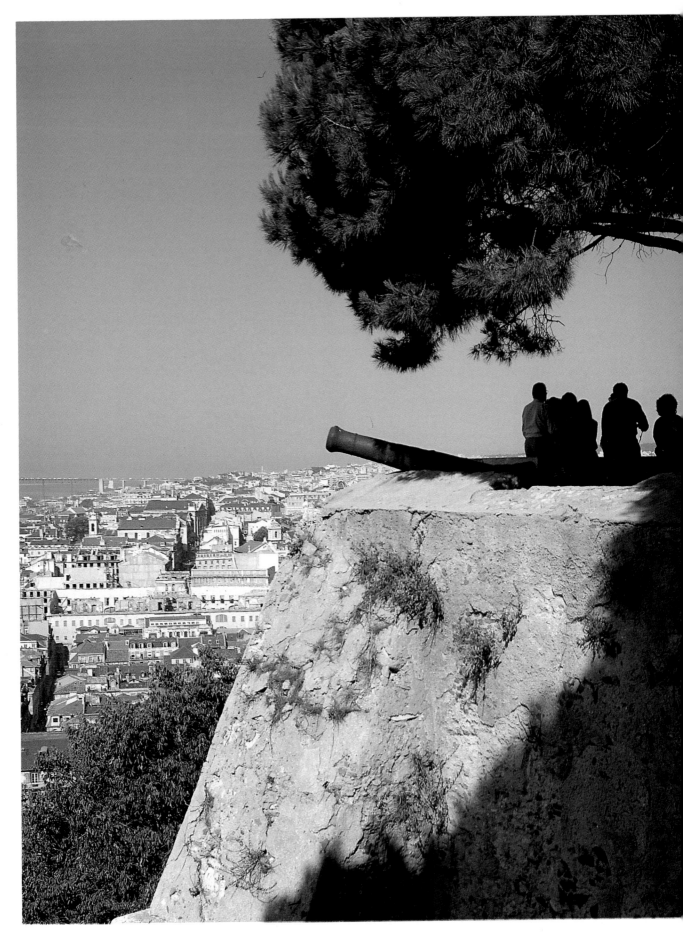

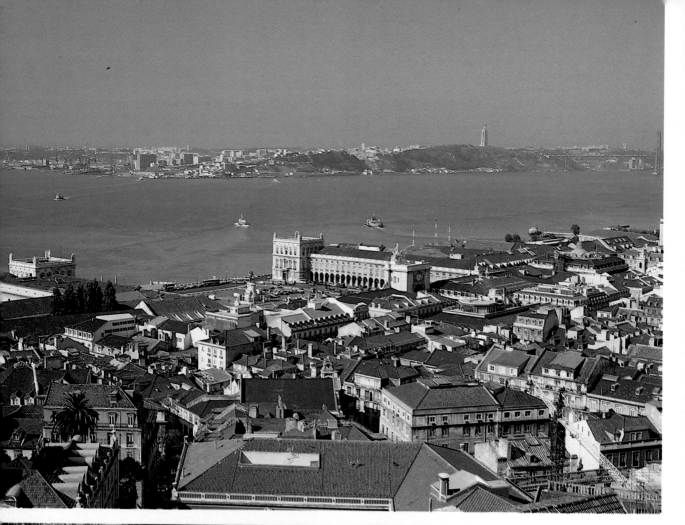

Magnificent views of the city from the look-out point at the Terrace.

Looking south-west across the Tagus.

A view of the Elevador de Santa Justa and the Carmo ruins amidst the densely-built Baixa quarter.

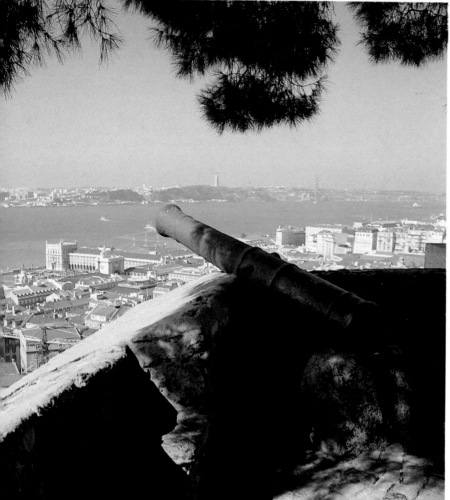

immortalised for ever by Malhoa, the painter who best caught the bohemian atmosphere of last century. Nowadays, most of its inhabitants are of Indian origin who have shops there. Mouraria, celebrated by the music of Amália Rodrigues, needs no further introduction.

The castle has more neighbouring attractions, among which is the famous Costa do Castelo. Constrained by the great fourteenth century walls, it leads down as far as the Baixa. It follows a route which is crammed with steps and narrow little streets with geranium-filled windows. This, and the surrounding area, is where the festivities are held in honour of St. Anthony.

Nowadays, swans, peacocks and other fowl live peacefully in the castle's inner gardens.

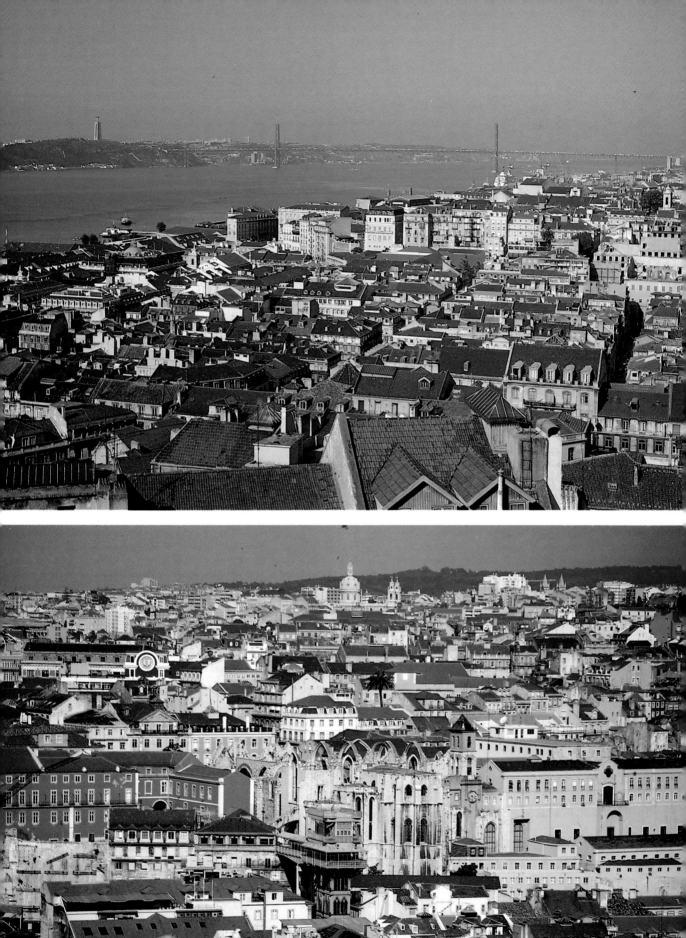

The XVIII century Church of Santa Luzia.

Miradouro de Santa Luzia lies in the heart of old Alfama.

Fountain at Santa Luzia belvedere.

Tile panel on the south wall of Igreja de Santa Luzia depicting Praça do Comercio before the 1755 earthquake.

SANTA LUZIA TERRACE

Lisbon is a city of hills which look out over the Tagus. This, in places, seems more like a sea than a river. The hills offer spectacular views, each different from the last, giving a new perspective on the city.

The **Santa Luzia Belvedere** enjoys a superb location below the castle in the Alfama district, next to the old castle wall, near **Portas do Sol**. The terrace garden is a calm place, with its colourful flowerbeds, and lies at the very heart of ancient Lisbon. Further down the road you can see the cathedral, further up lies Graça, beyond which are the Moorish mazes. The terrace leads onto the little steep alleyways that head up to the walls of St. George's castle.

The Santa Luzia terrace is a tiny garden which backs onto the small **Church of São Brás** - also known as Santa Luzia. The garden contains long wooden benches and others set into the walls in a vine-trellissed corner decorated with *azulejos*. It is an extremely pleasant place to sit, and its panoramic view stretches over most of the estuary, extending over the Sea of Straw towards Vila

Franca de Xira, and opening out in the west towards the Atlantic.

Opposite, the buildings and shipyards of Cacilhas stand ranged along the shore. The ferries and heavy shapes of the ships anchored along the shore glitter in the water. Back on this side of the river, you can see the colourful roofs that make up the complicated mosaic of Alfama, the **Church of Santo Estêvão** on the left and the **Church of São Miguel** further down facing the river. Also on the left, the white dome of the National Pantheon dominates the surrounding rooftops.

The exterior walls of the Church of São Brás, bordered with flowers, bear two panels of tiles. One is very detailed, showing Terreiro do Paço as it was at the beginning of the eighteenth century before the earthquake. The other tells the story of the bravery of Martim Moniz during the battles to conquer Lisbon in 1147: "While the Moors were in haste to close the gates of the Castle, Martim Moniz, a fearless Portuguese, obstructed them so as to afford passage, dying gloriously."

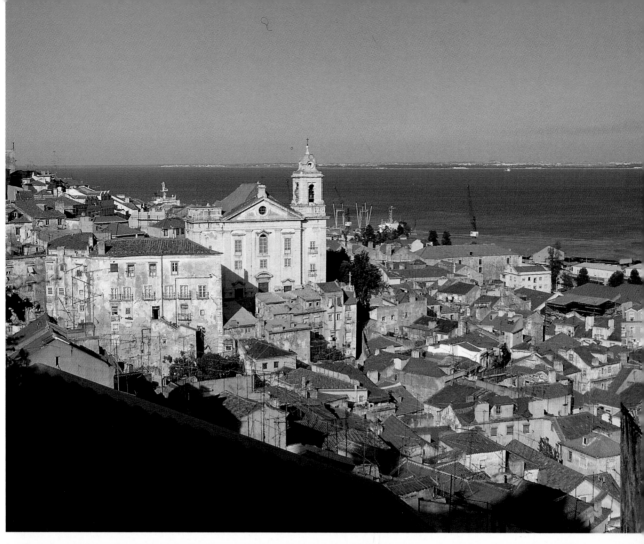

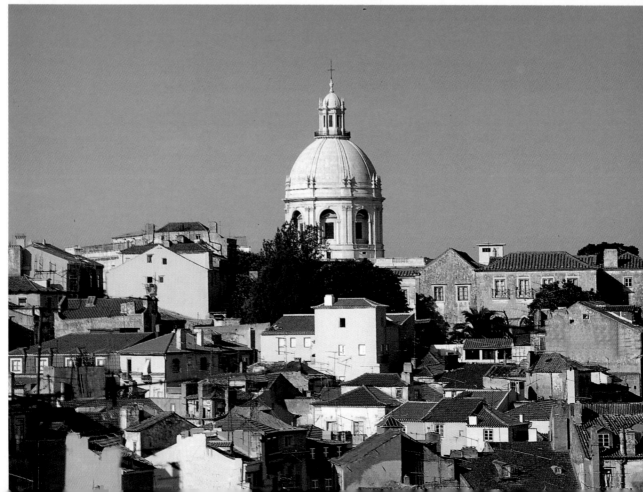

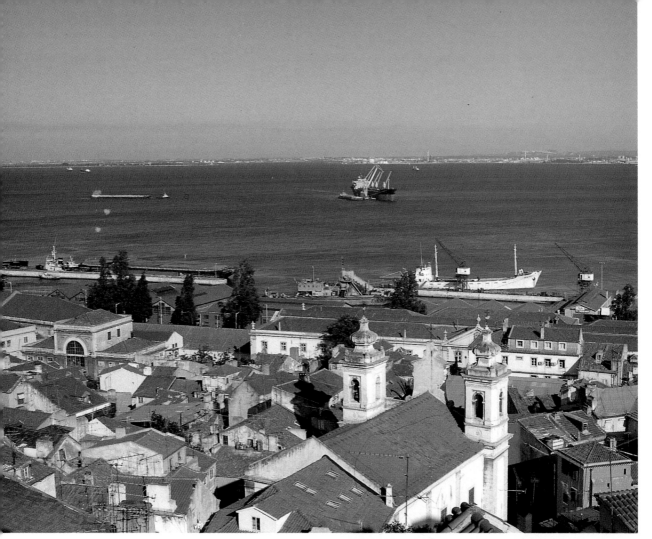

Panoramic view of the Alfama quarter, the harbour and the Tagus from the Santa Luzia belvedere.

The white dome of Santa Engrácia amidst the huddle of houses in Alfama.

Igreja de Santo Estêvão founded in the XIII century by King Dinis and rebuilt in 1773 to an octagonal plan. The north belfry collapsed after the earthquake of 1755.

A small bust of Júlio Castilho, historian of old Lisbon, can also be found in the garden.

A few metres below the terrace, is a pavement café, which you reach by descending a few stone steps. Slightly further up, next to the **Museum-School of Decorative Arts** is another café, the Portas do Sol.

The Higher Institute of Judicial Studies is located between the cathedral and the terrace in the former Limoeiro (Lemon Tree) Prison. This was the most important jail in eighteenth-century Lisbon, but had once been a royal palace steeped in history. It was here that the Master of Aviz killed the Count of Andeiro and where Leonor Teles took refuge afterwards. It was from the windows that the Master, the future King João I came to reassure the people. José I restored the building which was badly damaged in the earthquake. Near the entrance is an old and enormous tree, which probably replaced the original lemon tree.

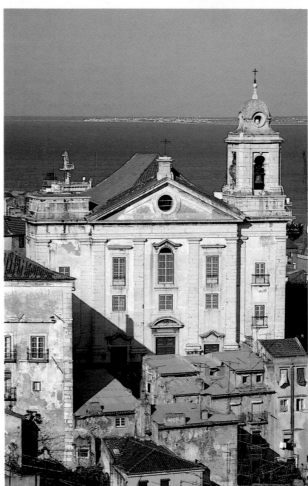

Houses with wrougth-iron balconies, a common feature in this old quarter.

A cobbled street in typical Alfama.

Alfama, a cobbled maze of narrow streets and old houses with a distinctive feel.

ALFAMA

This is one of the oldest and most traditional areas in the city, whose history goes back as far as the Arabs. The name **Alfama** comes from the Arabic *al-hamma* meaning hot springs, source of hot water. The area is typically Moorish: Alfama is full of blind alleys, hidden patios and endless flights of steps. Despite the earthquake, it has kept its characteristic narrow streets with houses whose roofs almost touch.

During the rule of the Muslims, Alfama was most likely a residential area for the aristocracy. With the victory of Afonso Henriques, the Christians moved in. In the thirteenth century, the growth of the population in the west of Lisbon pushed the Jews out from what is now the Baixa, forcing them south of the cathedral. Alfama gradually grew less important and became a poor district, mainly inhabited by fishermen.

In the early years of this century, Alfama was still considered "dirty and noisy", full of all "the emanations of poverty", as sung by "a whining and melancholic guitar". However, the claims that Alfama and neighbouring **Mouraria** were the birthplace of *fado* are not fully justi-

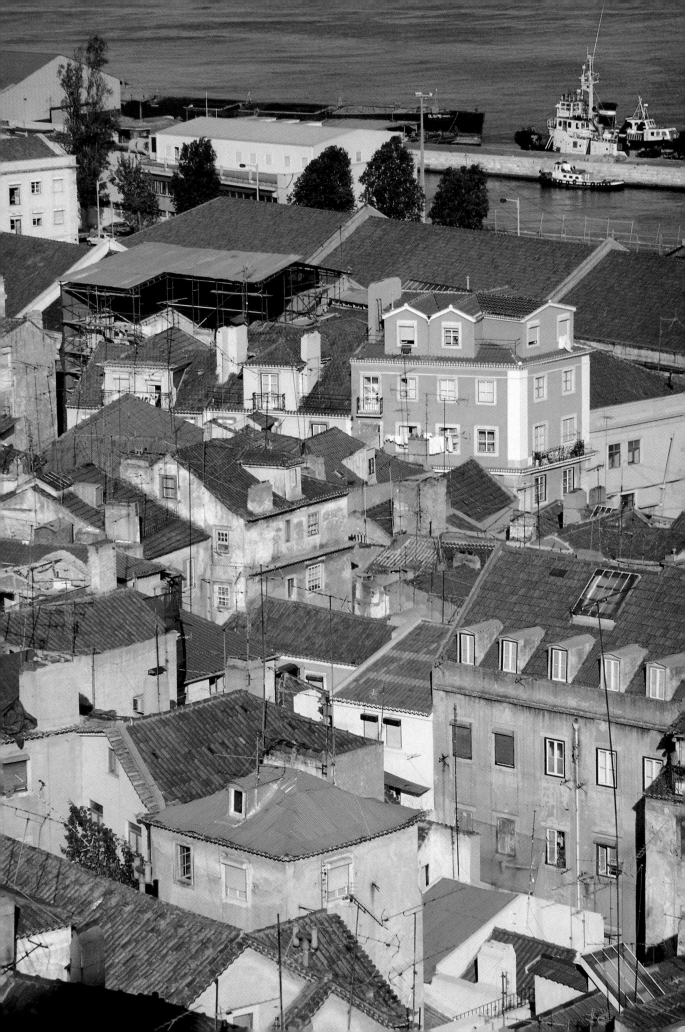

A primary school in an old place of residence.

One of the few fountains to be found in the old quarter.

Narrow streets, blind alleys, hidden patios, and endless flights of steps betray the essence of Alfama.

fied. The most likely story is that *fado* derives from a nineteenth century dance with Portuguese and Angolan influences, which existed in Brazil. Re-imported with the return of King Miguel, it quickly acquired great popularity, and became the *Portuguese national song*. Many Fado houses spread all over the city, however, the Liberal government, citing moral reasons, closed them down, only allowing them to open in these two districts. Alfama stretches from the *Largo do Chafariz de Dentro* by the shores of the Tagus, near the *Terreiro do Trigo Dock*, up to Campo de Santa Clara in one direction, and up to St. George's Castle in the other. Walking up through the unpredictable winding alleys, it is possible to see some of the few fifteenth century houses left in Lisbon, and a variety of curious arches, doors, windows and wrought iron railings.

The countless small *tascas*, or bars, and the last genuine taverns, with and without *Fado*, are still the main characteristics of this old district. During the *Popular Saints' Days*, Alfama is transformed into one enormous festival, in which the inhabitants of every street put up decorations and set up stalls to sell grilled sardines and wine.

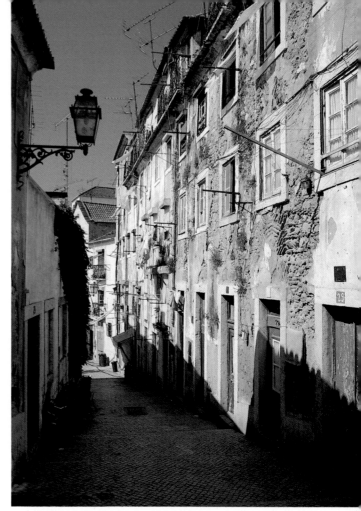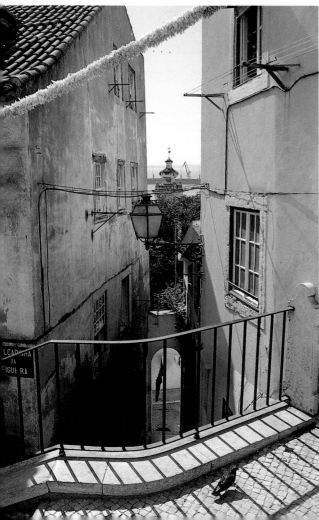

IGREJA DE SÃO VICENTE DE FORA

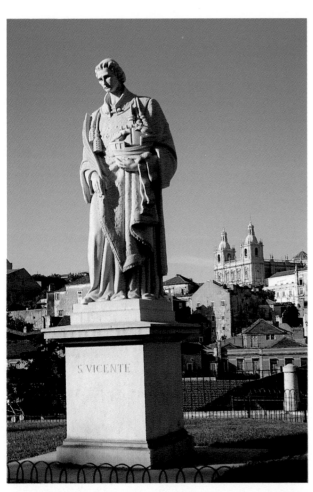

The church is one of the most important religious monuments in the city and can be seen from all over Lisbon. Its white limestone clearly stands out over the brick red roofs around it.

First built by Afonso Henriques, following the defeat of the Moors in 1147, it stands on the site where the Flemish and German crusaders pitched their camp. This allowed the first Portuguese King to keep a vow he made to St. Vincent during the 12-week military siege.

The current church is not the original built by King Afonso Henriques. It was pulled down and rebuilt in a completely different style between 1582 and 1627, by Philip II of Spain. After 1895, the new building underwent further alterations due to the the need for restoration work after the earthquake damage suffered a century before.

It is thought that the design for the sixteenth century reconstruction was by Filippo Terzi, who would have worked with the architect of the Escorial, Juan de

Memorial to St. Vincent (1970) at Largo das Portas do Sol.

The Igreja de São Vicente de Fora stands on a hill to the east of Alfama.

The imposing façade of São Vicente de Fora in the Late Renaissance style.

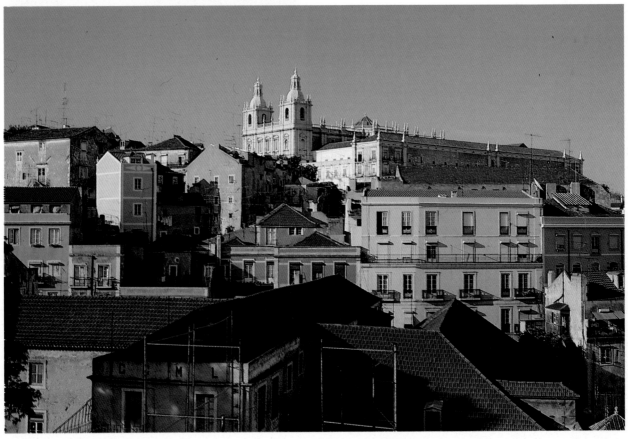

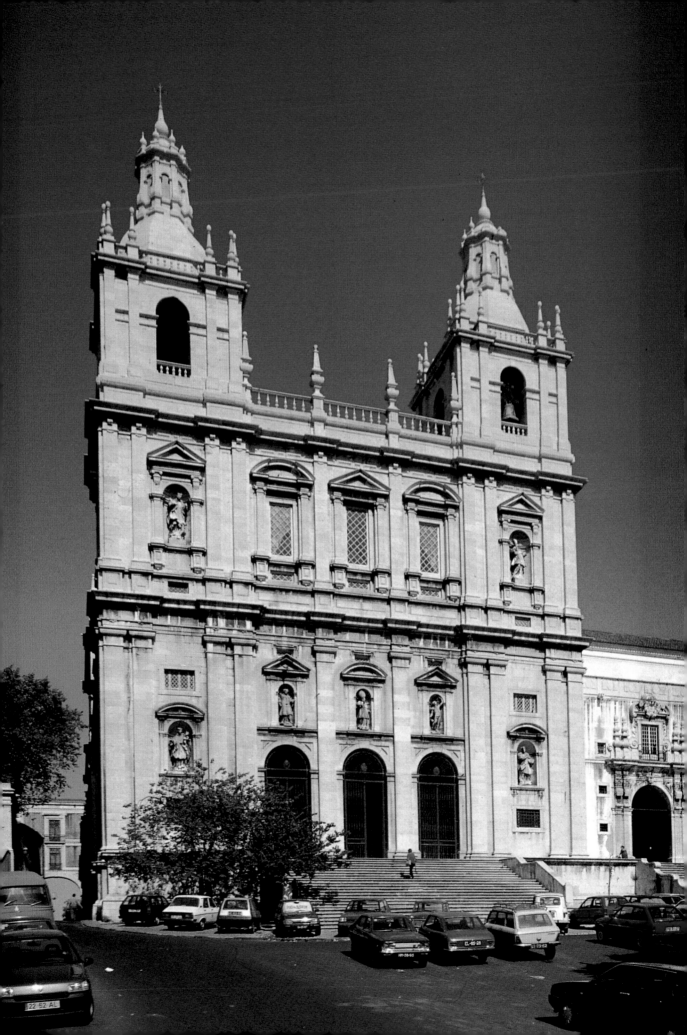

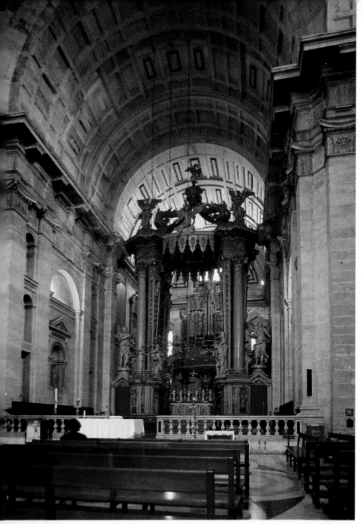

Herrera. However, work progressed so slowly, that no less than half a dozen other architects contributed to the design. The outstanding high altar was the work of the sculptor Machado de Castro, and dates from the eighteenth century.

The **Church of São Vicente de Fora**, *fora* meaning outside, is so called because the church stands outside the walls built by the Goths. In spite of its many alterations, it is a fine example of the Mannerist style - simple and harmonious. Its facade is made up of a central section, finished off by a balustrade, and two identical bell towers which stand either side of it.

Wide steps lead up to the entrance consisting of three round arches. Statues in niches decorate the facade, the three in the centre being St. Sebastian, St. Augustus and St. Vincent.

Its **interior** is considered one of the most balanced of the classical churches, despite being relatively small. The coffered barrel vault, which forms the body of the single nave, is decorated in black and white marble. It rests on sixteen pillars, between which the great windows let in the light.

The Altar of St. Vincent and its impressive Baroque canopy.

One of the two small cloisters where XVII century azulejos panels depict historical and secular scenes.

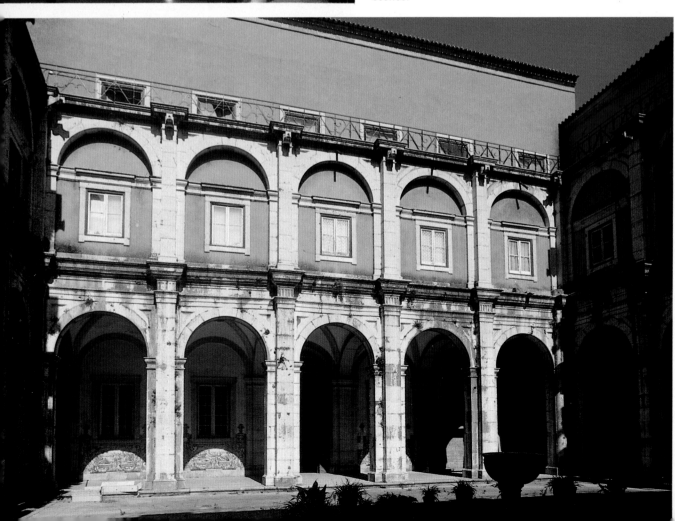

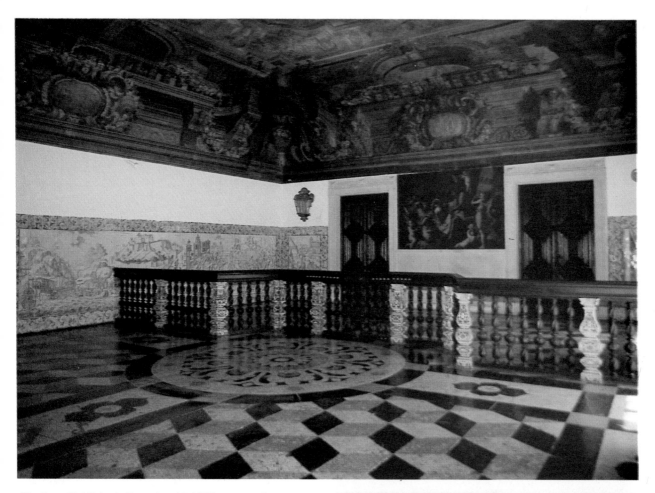

The beautiful Sala da Portaria with XVIII century tile panels depicting the conquest of Lisbon and the construction of São Vicente de Fora.

Portrait of D. Sebastião in the Sala da Portaria.

Following pages: scenes of fashions and daily life depicted on typical XVIII century azulejos panels that line the walls of the cloisters.

Of the church's chapels, the **Chapel of Nossa Senhora da Conceição** should be noted. It is richly decorated and dates from 1698. The chapel of St. Anthony has a tombstone with an epitaph that reads that the bones of Teresa Taveira, his mother lie there. In the same place is the tomb of Henrique Alemão, a knight killed during the siege on the Moors.

In the vestibule of the monastery, there is a valuable collection of *azulejo* panels, dating from the first half of the eighteenth century. Painted by Manuel dos Santos, they represent the taking of Lisbon and Santarém. The ceiling was painted by Vicente Baccarelli in 1710, and shows the triumph of the Church over the Mannicheans. In the sacristy are precious ornaments in different tones of marble, and in the cloisters, there are panels of tiles with courtly scenes and others illustrating de La Fontaine's fables. Also of note is the superb organ, another eighteenth century-masterpiece.

The former refectory now serves as the Pantheon of the Royal House of Bragança. Fernando II ordered the Pantheon to be moved there in 1855, and it now houses the tombs of several monarchs.

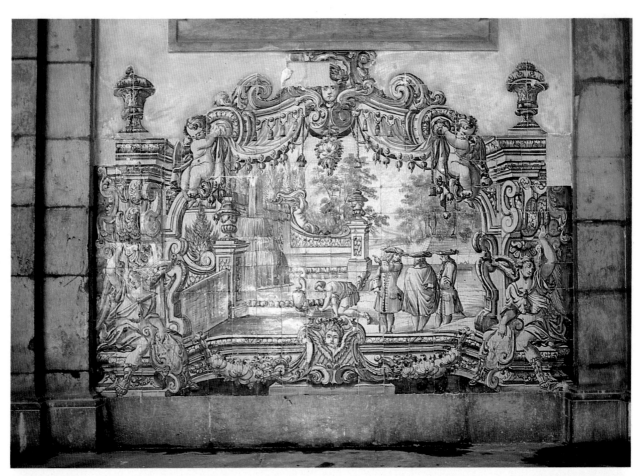

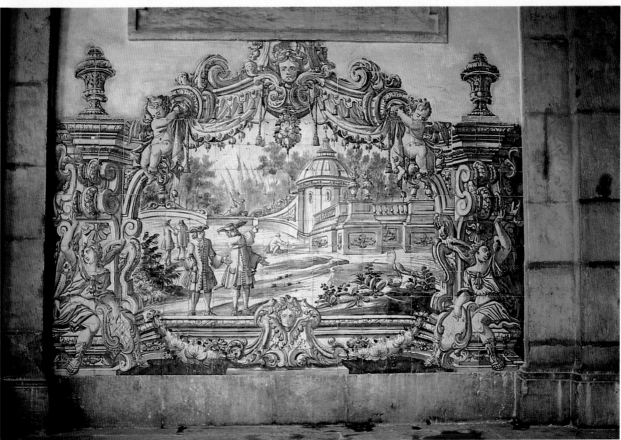

54

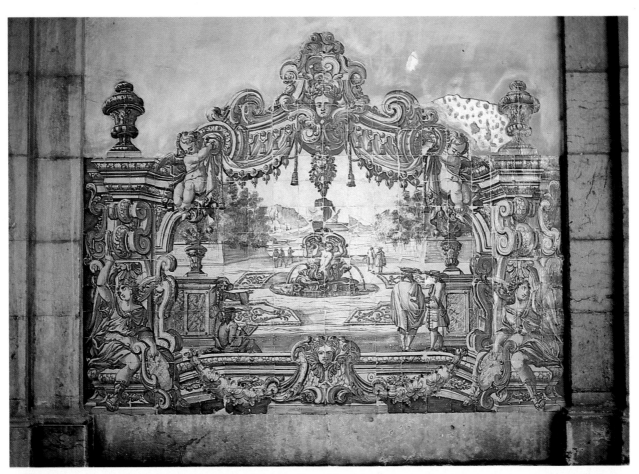

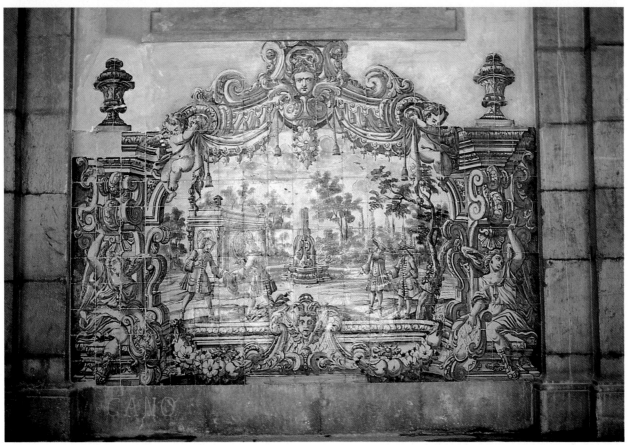

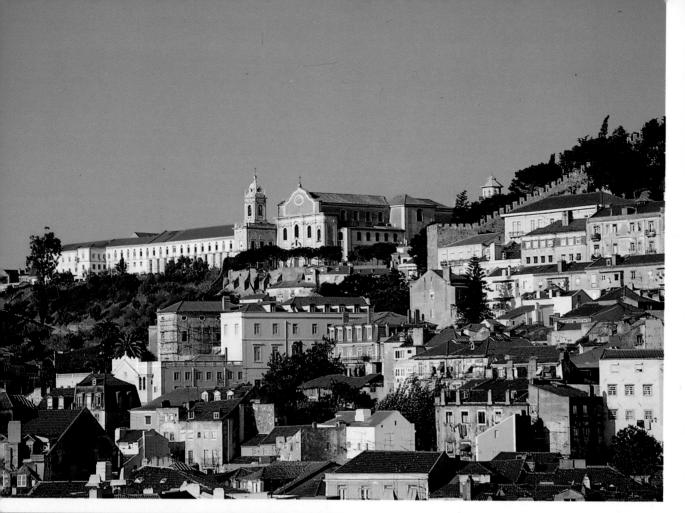

The Church and monastery of N.S. da Graça lies on a hill north-east of St. George's Castle.

The Baroque facade and the detached belfry.

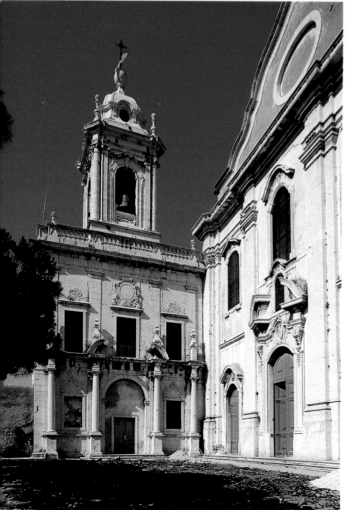

IGREJA DE NOSSA SENHORA DA GRAÇA

Although the building dates from 1271, nothing remains of the medieval structures, as it was rebuilt in the mid-sixteenth century. It was restored in the eighteenth century, underwent major repair work after the earthquake and complete restoration between 1896 and 1905.

Founded by the Augustinians, the monastery moved twice before settling definitively on the current site. The monastery was the headquarters of the order, could house 1,500 people and was considered the richest in Lisbon. In 1834, the church was given to the brotherhood of the Senhor dos Passos, which organises the most popular religious procession in the city. The monastery was then turned into a barracks.

The current church, consisting of a single nave, was designed by Caetano de Sousa. There are paintings by João Vaz, Éloi de Amaral and Pereira Cão. The walls covered in seventeenth- and eighteenth-century *azulejos* deserve special attention, especially those in and leading into the sacristy. Tiles also decorate parts of the old monastery.

The **facade**, which leads on to a terrace affording a splendid view, stands at a right angle with the old vestibule. It is topped by the famous eighteenth century **bell tower** by Manuel Costa Negreiros.

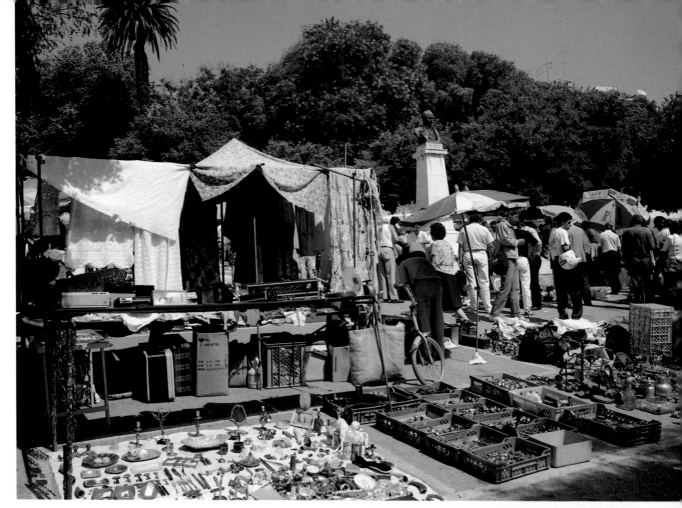

Lisbon's best-known flea market at Campo de Santa Clara near the Church of São Vicente de Fora.

FEIRA DA LADRA

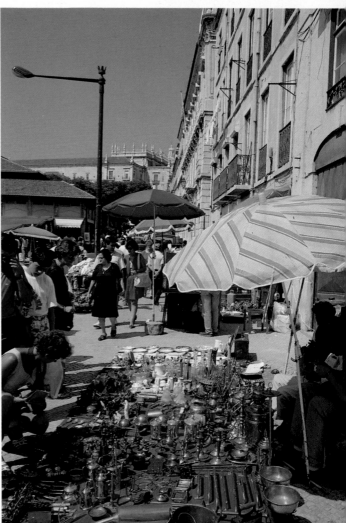

The **Feira da Ladra**, or Thieves' Market, has been held every Tuesday and Saturday since 1882 in the spacious Campo de Santa Clara, hugging the hillside between the back of São Vicente de Fora and the National Pantheon. The origins of the fair go back much further, to the early days of the Reconquest.

Amongst the theories on the origins of its name, the most consistent seems to be that *ladra*, or thief, is a corruption of *lada*, or side, as the flea market was first held right next to the shores of the river Tagus. There are, however, other stories, which tell of less legal beginnings.

The market today is on the site of a Franciscan monastery founded by King Dinis, totally destroyed in the earthquake, burying more than four hundred people. Nowadays, twice a week, there are bustling crowds of buyers and sellers, regulars and visitors.

There is a very wide choice of items on sale, some from established traders, others from traders who only appear now and then. You can find new merchandise, from clothes and televisions and radios to furniture and different household electrical items, as well as machine parts, old watches, curios, magazines and books. With patience and clear thinking, there are bargains to be had, as there are no fixed prices.

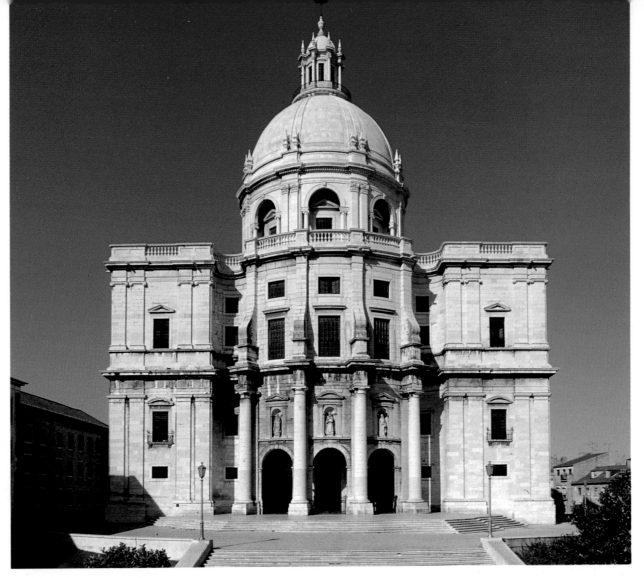

The church of Santa Engrácia, in the form of a Greek cross, was begun in 1682.

The dome was finally completed in 1966 and the church has since become the National Pantheon.

The dome rests on pendentives formed by four semi-cupolas; a view down into the interior from the drum of the dome.

IGREJA DE SANTA ENGRÁCIA - NATIONAL PANTHEON

Founded in the sixteenth century, and rebuilt the following century, the **Church of Santa Engrácia** is one of the most impressive examples of seventeenth century Baroque. It is the first example of the strong Italian influence on this style in Portugal.

This building replaced the church built by the daughter of King Manuel, the Infanta Maria. It was demolished in 1630, after it had been discovered that a Jew, Simões Pires Solis, burnt alive for having been unjustly accused of stealing from the tabernacle, had said nothing whilst being tortured in order to hide his love for one of the Santa Clara nuns.

Building got underway first with the designer João Nunes Tinoco. However, it was not until 1682 that work progressed at a faster pace, overseen by the architect João Antunes, who also helped design the new church. The building showed all the signs of opulence of the reign of King João V, by way of grandeur of scale. However, the church had to wait until 1966 for completion. In fact, the central dome in the original design was not built, as it was feared that it would be too heavy, so it was only a little more than a quarter of a century ago that the *National Monuments Authority* actually built it, although not to the proportions initially desired.

The church is octagonal, centred on a round-armed Greek cross inscribed in a square reminiscent of St. Peter's of Rome. In the entrance is a beautiful doorway with twisted columns in pink marble, designed by the Frenchman Claude Laprade. Officially designated **National Pantheon** in 1916, it only began to serve this purpose fifty years later, after some of the tombs at Jerónimos Monastery were transferred. At the same time the floors were restored, together with the statues inside and outside the building.

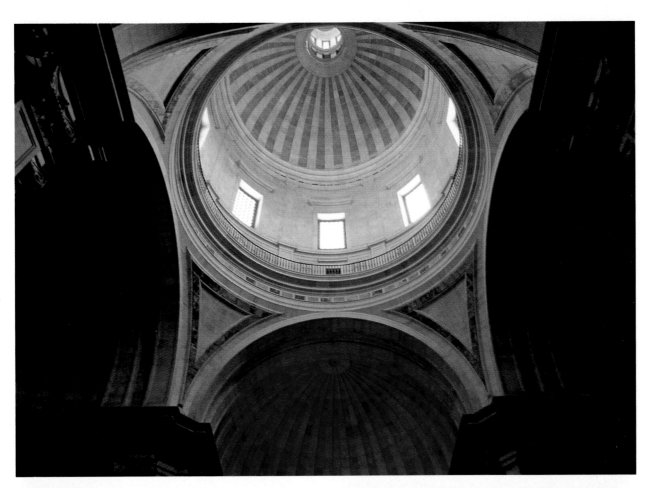

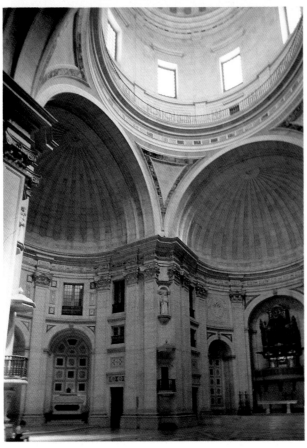

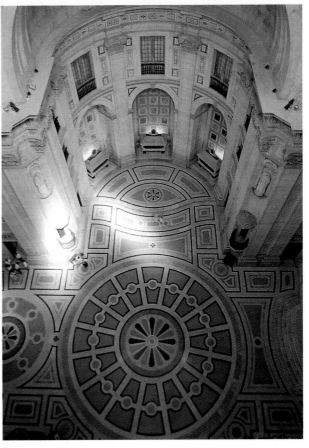

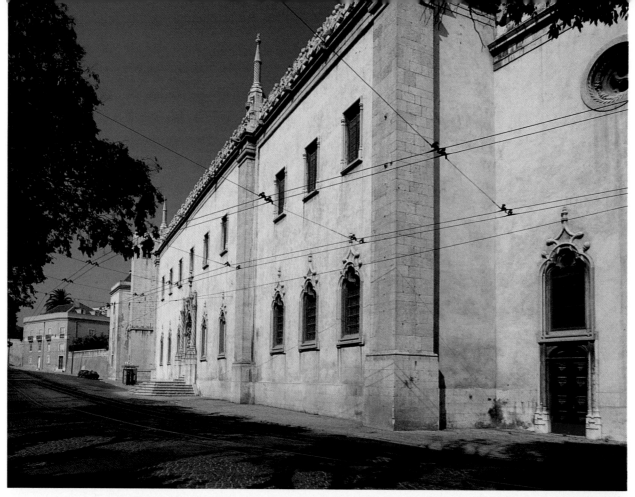

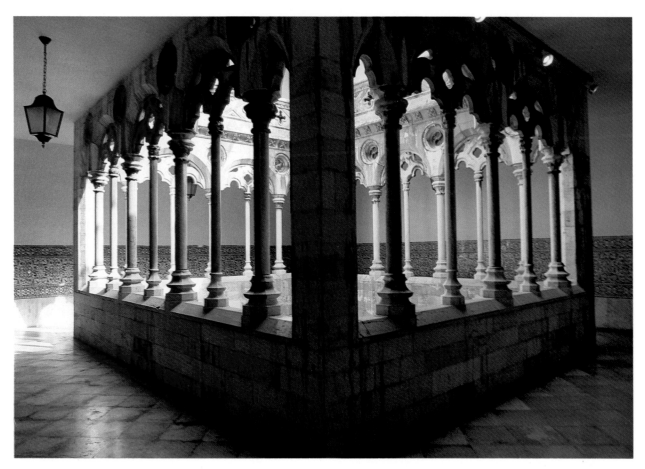

The Church of Madre-de-Deus (1509) rebuilt after the earthquake in 1755 has preserved a Manueline doorway from the original building.

The National Tile Museum is housed in the monastic buildings of the Igreja da Madre-de-Deus.

The Manueline Cloister.

MUSEU NACIONAL DO AZULEJO

The museum is housed in the old **Convent of Madre-de-Deus** in Xabregas, founded by Queen Leonor in 1509. It is an open and bright place, cool and silent. During construction, the waters of the river came so close that for a long time, they threatened both the building work and the faithful. It has undergone several changes and restoration projects in its time, mainly during the reign of King João III, and in the eighteenth and nineteenth centuries, when under the direction of architect João Maria Nepomuceno, the Manueline facade, which had disappeared, was reconstructed. The portico is decorated with small, twisted columns crowned with pinnacles and trilobate arches, featuring a pelican and a shrimpnet - symbols of the founder and her husband, King João II. It is in fact a replica of the original, which was inspired the Santa Auta panels, in which the early church figured in the background.

The convent contains vivid examples of the history of sacred art and of course *azulejos*. It also has within its confines the **Church of Madre-de-Deus**, one of the most beautiful in Lisbon. The church is decorated with rich gilded wood carvings and has fine paintings and panels of blue and white ceramic tiles from Holland. The interior of the convent is divided into rooms ranged around the two cloisters, built and altered as the convent grew. This, and the museum's collection from down the ages, shows the history of tile art in Portugal.

The museum is relatively recent. In 1959, in the wake of works to prepare for an exhibition on Queen Leonor, the founder of the convent, the idea was mooted to use the space as a tile museum and take advantage of the many panels of *azulejos* in the convent. The museum opened its doors in 1965 under the guidance of João Miguel Santos Simões, an expert in the field, and with the help of the Calouste Gulbenkian Foundation.

In its early years, the museum functioned as merely a section of the National Museum of Ancient Art. The bulk of its acquisitions were tiles made before the nineteenth century. In any case, nineteenth century tiles were nearly all to be found on the facades of private houses, and sold exclusively according to the will of the owners. In 1980, the museum acquired the status of national museum, and the following years were spent organising it, and researching and recording the history and value of the collection of this quintessentially Portuguese art form, which now includes contemporary work.

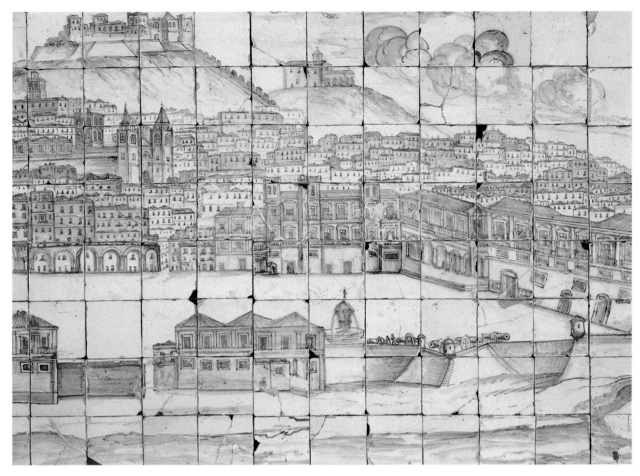

Detail of Terreiro do Paço from a tile panel depicting Lisbon before the earthquake of 1755 (height 111,5 cm).

Polychrome azulejos panels of Nossa Senhora da Vida (1580) made up of 1384 tiles depicting the Nativity scene, 500 x 465 cm.

Coat of arms of the Dukes of Braganza (1558), 27 x 54 cm.

The museum illustrates how the five-thousand-year-old art evolved in Portugal, from the glazed tile work from Granada and the *cuerda seca* of Hispano-arabic tile art, to the current day, demonstrating the main techniques of manufacture.

Ceramic tiles were used in several countries in Europe, even before Portugal, but it was here that they became fashionable in ornamental art. They have evolved and changed throughout the centuries, adding grandeur and character to other arts, especially architecture.

Portuguese tile work has had several influences, examples of which can all be found at the museum. Tiles only began to have truly Portuguese characteristics during the sixteenth century. Since then, they have been used on a much wider scale, and it is almost impossible to find major buildings which do not have at least one example of tilework in their decoration. The Italian renaissance is one of the first European influences to have reached the peninsula. Then followed influences from Seville and Talavera in Spain, where the first imitations of rich cloth were made, as well as altar frontals - ceramic copies of the luxuriant textiles that covered the altars in churches. Also to be found in the museums are examples of the

oriental and Flemish arts, the latter of the sixteenth and seventeenth centuries, showing how tiles have evolved. This can be seen both in the panels created by gifted painters, or through the simple designs of modest artisans. The different colours used up to the end of the seventeenth century show the freedom of design from the manganese patterns, and the purely blue and white tiles of Flemish influence, dating from the return of the masters to the authored panel. It was in the eighteenth century that Portuguese ceramic tile art really became established in its own right. Brazilian gold was lining many people's pockets, and secular architecture in this period competed with and sometimes surpassed religious architecture in splendour. Among the artists who painted mythological scenes, scenes from the Restoration of Independence and paintings depicting everyday life - typical of the Baroque period - António de Oliveira Bernardes deserves special mention. The museum contains several examples of these panels, which celebrate life as the most important art. They are adorned with curtains, like stages depicting scenes of hunts, court life, stories and landscapes.

There are many pieces on display, including the noted

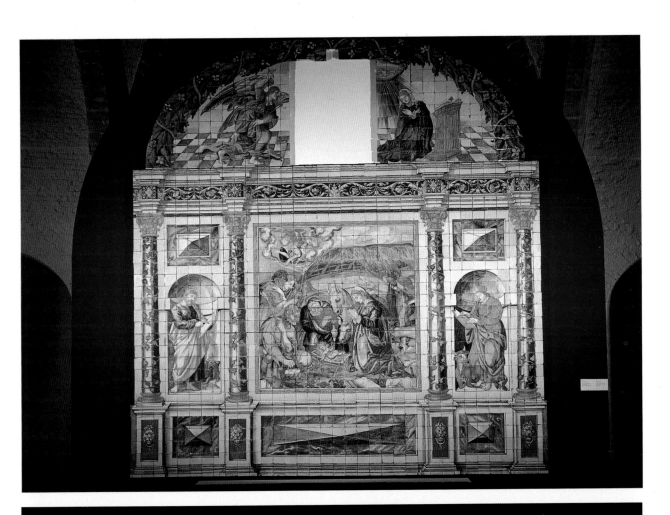

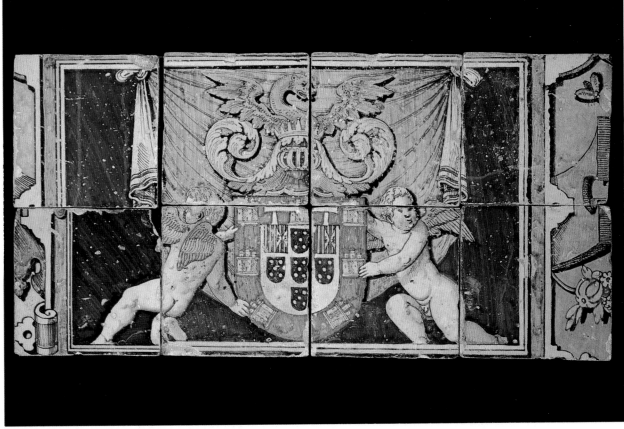

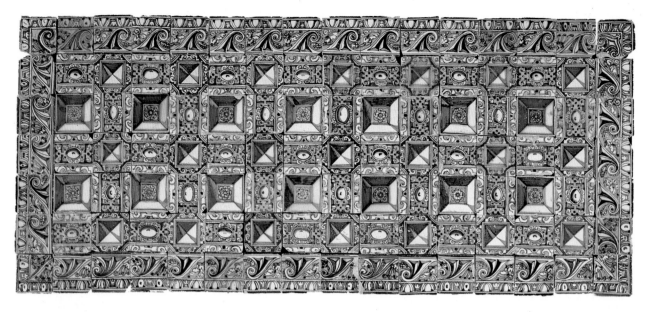

Tile panel with diamond motif (XVII c.) 209,7 x 95,7 cm.

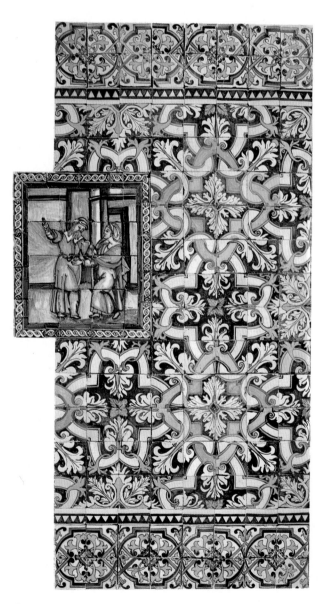

sixteenth-century retable, thought to be dedicated to *Nossa Senhora da Vida* and a panoramic panel of Lisbon. The former, probably by Marçal de Matos using the *maiolica* technique, is made up of 1,384 polychrome tiles, covering an almost square-shaped surface of 23 square metres. St. Gabriel, the Virgin of the Anunciation, the Adoration of the Shepherds, St. John the Evangelist and St. Luke all figure in the Mannerist style panel. The panel of Lisbon features a detailed panoramic view of the city between Cruz Quebrada and Xabregas, prior to the great earthquake. It is made up of 1,300 blue and white ceramic tiles and is approximately 23 metres long.

The museum also contains examples of post-earthquake tiles, which are simpler and feature repetitive motifs. Towards the end of the eighteenth century, colour began to feature again in ceramic art, and has stayed to the present day. Despite the fact that famous names in the nineteenth century, such as Jorge Colaço and Rafael Bordalo Pinheiro, only touched upon tile work, preferring instead other forms of art, the twentieth century brought a new interest in ceramics. In fact, contemporary Portuguese ceramic art has been created by prestigious artists such as Jorge Barradas, Maria Keil, Almada Negreiros, Cargaleiro, Querubim Lapa, Carlos Botelho, Sá Nogueira, Júlio Pomar, Eduardo Nery, João Abel Manta, Lima de Freitas and Vieira da Silva, among others. One example of the recent renewed interest in the art of the *azulejo* can be seen in the Lisbon Underground, where the stations are decorated in contemporary style.

Typical XVII c. patterned design of a tile panel with religious scene, 240 x 141,5 cm.

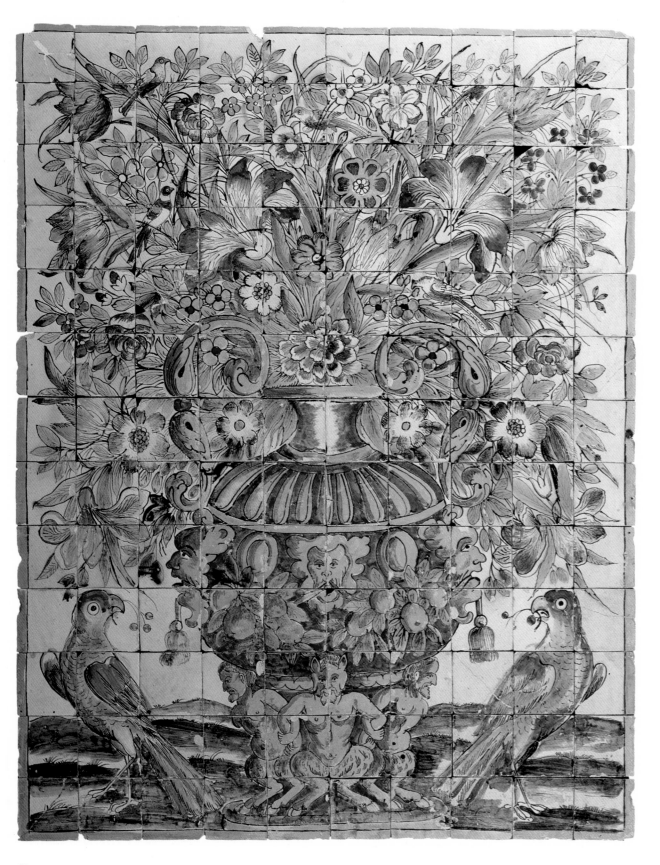

Flower vase on a panel from the former convent of
N.S. da Esperança, Lisbon (XVII c.) 185 x 142 cm.

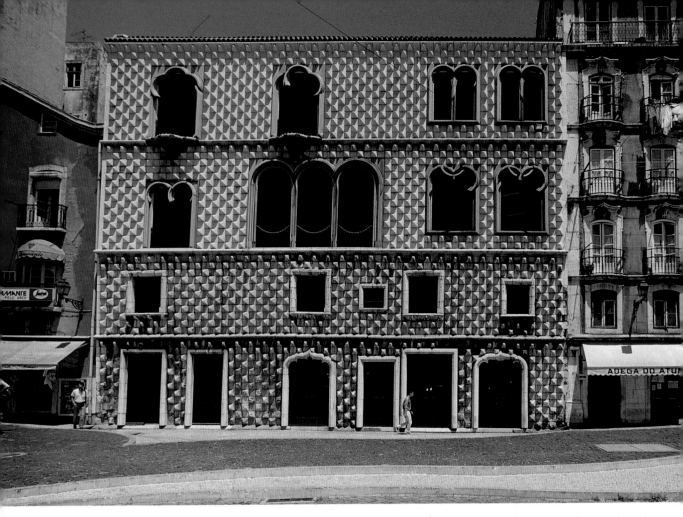

Casa dos Bicos (1523) a rare example of Renaissance architecture in Lisbon.

The beautiful Manueline portal of the Igreja da Conceiçao Velha built in the early XVI century.

Details of the trumeau and the intricately carved support of the archivolts.

CASA DOS BICOS

The **Casa dos Bicos** - House of Pointed Stones - was built in the first half of the sixteenth century on the site of the residence of the family of Afonso Albuquerque (1460-1515), the most famous of the Portuguese governors in India. It was built by the viceroy's son, christened Brás, but later known as Afonso, as decreed by King Manuel to whom he was a counsellor, so as to carry on the name of his father.

The building is a rare example of sixteenth century secular architecture in Lisbon. Its facade is unusual - covered in diamond-shaped stones, similar to the *Casa de los Picos* and the *Palazzo dei Diamanti* - in Segovia and Ferrara respectively, both built in the same period. At the time of construction, the building, which the proud Brás (Afonso) wanted to be superb and unique, stood right on the banks of the Tagus where ships arrived laden with silks and spices from the Orient. It apparently used to have four storeys and cover a larger area, but the earthquake reduced it to just two storeys. The passing of time rerouted the river.

Also known as the *Casa dos Diamantes* - House of Diamonds, the building was subjected to controversial

major structural work at the beginning of the 1980s. Two more storeys were built with large arched windows, which have now been glazed, so that the building could be used as one of the five centres of the seventeenth Exhibition of European Art, Science and Culture, which took place between May and October 1983. Nowadays, the Casa dos Bicos houses the *National Commission for the Commemorations of the Portuguese Discoveries*.

Near the Casa dos Bicos is the **Church of Conceição Velha**, built by King Manuel at the request of Queen Leonor. It is dedicated to Nossa Senhora of Mercy, and was built on the same site as the former Jewish Synagogue. Its architecture is Manueline, and it was designed by the artists who also designed Jerónimos Monastery. According to the history books, the church was extremely beautiful. However, the earthquake destroyed much of its beauty, leaving only the Chapel of the Holy Sacrament which dates from the end of the sixteenth century, and part of the south portal flanked by two windows, reminiscent of the doorway of the Jerónimos, facing the Tagus.

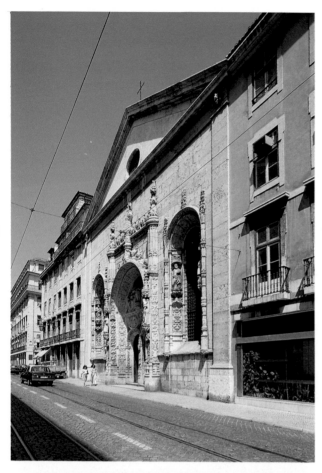

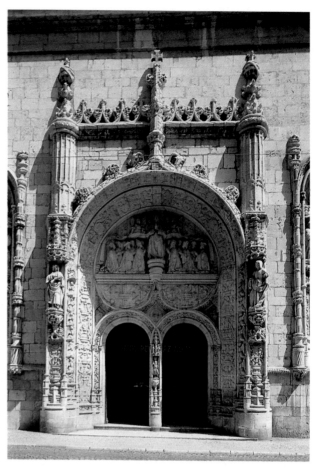

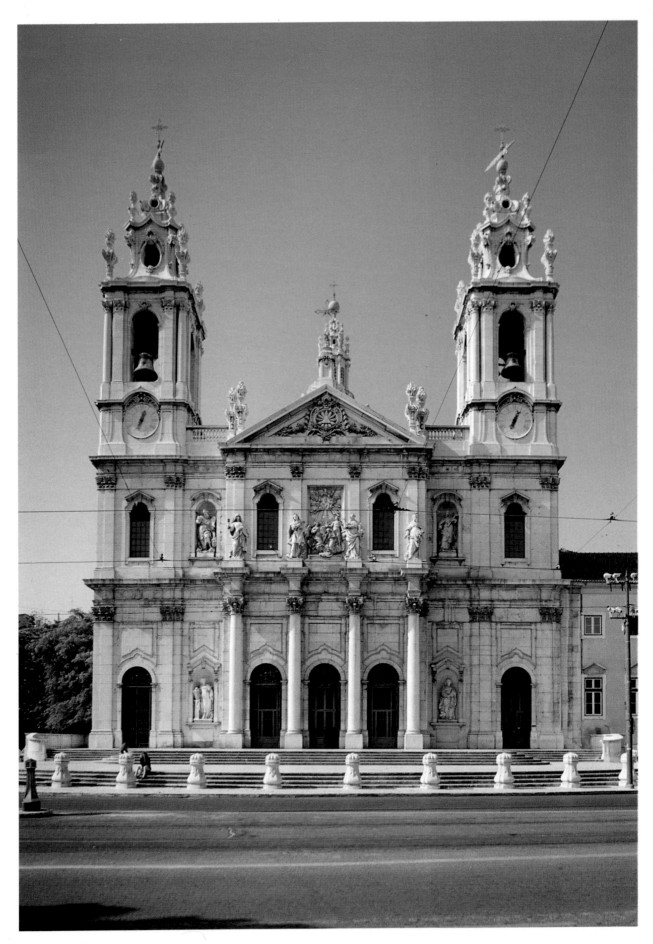

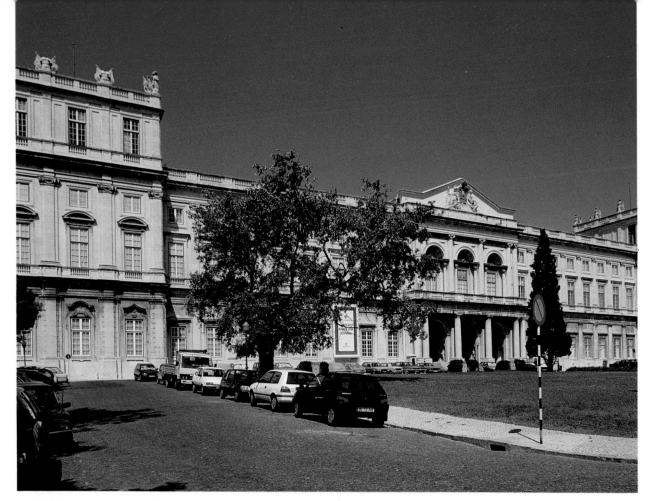

Basilica da Estrela was built by Queen Maria I between 1779 and 1790, in the Late-Baroque style.

The imposing facade of the Palácio da Ajuda (1802).

BASÍLICA DA ESTRELA

Built in the neoclassical style, the Basilica of the Sacred Heart - known just as the **Basílica da Estrela** - is one of the last examples of the school of Mafra, and is one of the most significant eighteenth century buildings in Lisbon.

The church was built between 1779 and 1789, firstly to the design by Mateus Vicente de Oliveira. He died in 1786, and so Reinaldo Manuel took over. The Basilica was built as a result of a vow by Maria I - who is buried there - to the Sacred Heart, asking for the blessing of a son - an heir to the throne.

The **main facade** comprises three sections, the central section topped with a pediment. Four columns support the statues of Faith, Adoration, Freedom and Gratitude, works by the school of Machado de Castro, the sculptor who was responsible for the bas relief on the facade.

As all the artists were from the school of Mafra, there was great uniformity and harmony in the design. The interior is remarkable for its size and impressive materials. Of special interest are the *Nativity Scene*, and the black marble tomb of *Brother Inácio de São Caetano*, the confessor of Maria I, also attributed to Machado de Castro.

PALÁCIO DA AJUDA

The Old Palace - which was made of wood to temporarily house the royal family, ousted from the Ribeira Palace by the earthquake - has had an eventful history. In 1794, it was destroyed in a fire and work to rebuild was not started until 1802, continuing to the end of last century. In 1976, another fire gutted the picture gallery, built by King Luís.

The palace was built to original plans by Francisco Xavier Fabri, with several alterations, many by Manuel Caetano de Sousa. The limestone **facade** - one of four in the initial plans - is enormous. The central section has three great windows over the porticos, spaced between Doric columns.

In the vestibule, there are forty seven marble statues in the Italian style, three by Machado de Castro, and the others by six other sculptors. Some of the more well-known artists of the period painted the walls and ceilings.

The interior of the palace is furnished with beautiful Portuguese works of art, mainly from the last century.

69

The main entrance of the Museu Nacional de Arte Antiga leads into the original XVII century palace.

MUSEU NACIONAL DE ARTE ANTIGA

It is not known who designed the seventeenth century Palace of the Counts of Alvor. The Távoras - a family of high nobility, all but wiped out with astonishing cruelty by the Marquês de Pombal - are also tangled up in its history, as well as the Marquês himself and his brother, who bought the building. There is even a Carmelite convent involved - the Santo Alberto convent - which was located nearby and underwent the necessary reconstruction to join it to the palace in 1937, at that date already converted into the National Museum of Ancient Art. The building began its artistic career as the *Royal Museum of Fine Arts and Archaeology* in 1884, when measures were finally taken towards finding somewhere to store and protect the precious haul collected in the wake of the Liberal Revolution.

Work had begun back in 1868, thanks to the energy and enthusiasm of the Marquês de Sousa Holstein, tired of the lethargy which threatened the magnificent works of art. The works were at that time being stored in Lisbon in the Academy's National Gallery, which had been specially created for this purpose at the Convent of São Francisco. His fears were justified - the works were piled up haphazardly, and were at the mercy of the less conscientious visitors, not to mention the damage caused by damp, dust, moths and other pests.

However, in spite of the laudable work done by the Marquês, the situation still left much to be desired. In 1875, he headed a committee which called for a museum to be set up. Six years later, the project got underway, with the help of Delphim Guedes, the Academy's vice inspector, and in 1879 the Palace of the Counts of Alvor, also known as Janelas Verdes - Green Windows - was rented. The aim was to hold the Exhibition of Ornamental Art there. This was a large exhibition of Portuguese art which had already been shown in London to enormous success. When it opened in 1882, it continued a resounding success, and was seen by more than 100,000 visitors.

The *Museum of Fine Arts and Archaeology* opened on 11 May 1884, and underwent alterations in 1910. Under the direction of José de Figueiredo, the layout and design of the exhibition halls were rethought in pioneering vein, with special regard given to painting.

One year later, the museum divided in two, becoming the National Museum of Ancient Art and the National Museum of Contemporary Art, the former remaining in the Janelas Verdes. Throughout its history, the museum has spawned a number of other museums, owing to the richness and variety of its treasures. The National Coach and Costume Museums both grew out of Janelas Verdes.

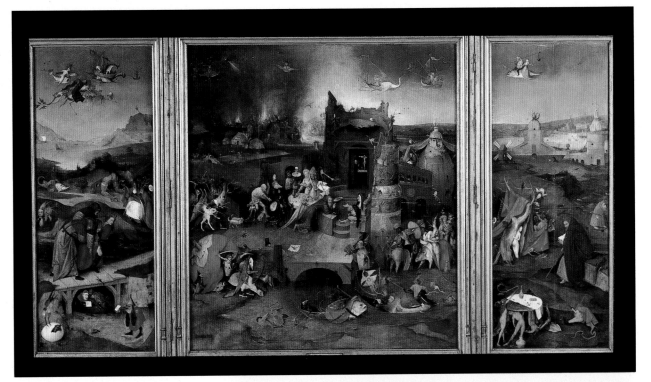

The triptych "Temptation of St. Anthony" (c. 1500) oil on wood by Hieronymus Bosch.

"St. Jerome" (1521) oil on wood by Albrecht Dürer, 59,5 x 48,5 cm.

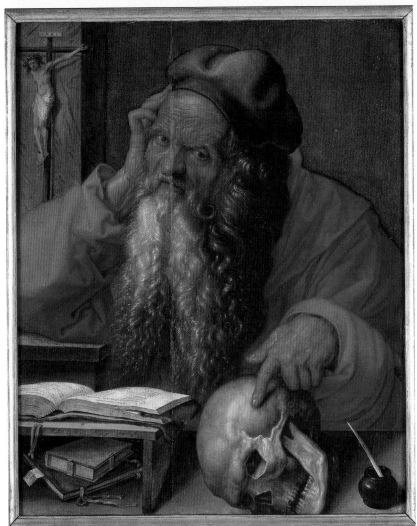

The "mother" museum continues to house many beautiful treasures, representing an enormous range of arts of all ages. As the **National Museum of Ancient Art** is in fact many museums in one, a visit there is like a round-the-world trip. From voyages to the Orient, through the Chinese porcelain or the **Namban screens** - the art where the painters in faraway Japan told of when they met the Portuguese - to Europe, with art influenced by other civilisations, which started with the Discoveries, in Asia and Africa, as well as Portugal.

The museum has a heritage rich in everything from painting to sculpture, furniture, ornamental arts such as ceramics and glass, carpets, ivory and the beautiful jewellery. The prosperous times of the kingdom can clearly be seen through these works of art, those from Portugal as well as from abroad. The museum's foreign art collection covers eight centuries, as does the Portuguese collection.

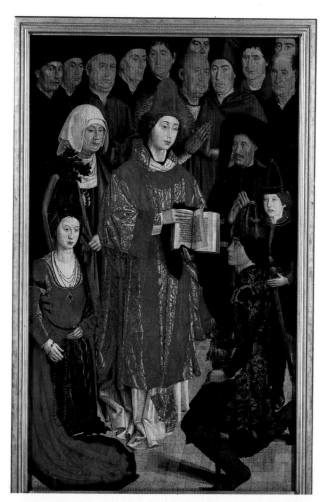

If the pieces seem to represent the more religious side of art, this is because works have been kept through the years, specifically because of their religious character. The same is not true of works with no religious significance, as their style changed whenever necessity or fashion dictated.

The most impressive of the foreign pieces is the **Germain dinner service**. However, the exhibits in the museum are copies, as the originals, which were commissioned by João V from the famous Frenchman Thomas Germain - who inherited his name and talent from his father Pierre Germain, goldsmiths to Louis XIV - disappeared in the 1755 earthquake. The current service, which is incomplete, was made on the orders of José I by François-Thomas Germain, the grandson of the Sun King's craftsman. Problems got in the way, not least the artist's going bankrupt, so manufacture of the set was never finished as planned. The ostentatious dinner service was not complete, but it was nevertheless used for the first time with great pomp and circumstance on 13 May 1777, at the coronation of Maria I.

The variety of the collection means there are rare and dazzling pieces to be seen, many of them steeped in mystery, such as the famous **Panels of São Vicente de Fora,** a masterpiece of fifteenth century Portuguese painting, oil on oak wood, attributed to Nuno

"Panel of Henry the Navigator" one of the six screens attributed to Nuno Gonçalves from the polyptych (XV century) found in the Monastery of São Vicente de Fora, 207 x 128,5 cm.

Namban screen (1593-1600; tempera on paper) depicting the arrival of the Portuguese in Japan, 178 x 366 cm.

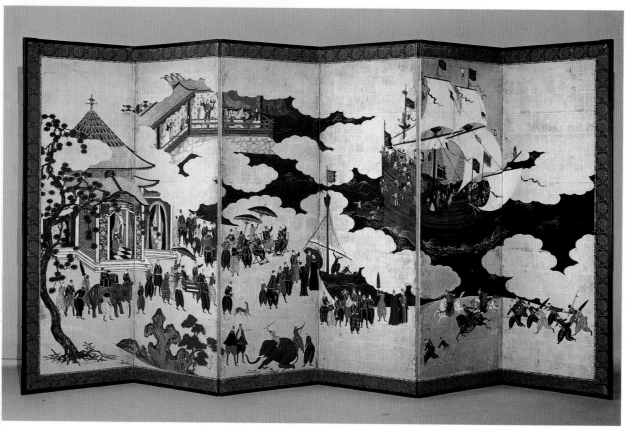

Gonçalves. Some questions remain unanswered, from the identity of the people portrayed in the piece, to their position - there are sixty figures painted on six panels, in which the saint is depicted twice among fifty three adult men, two women and a boy. This wonderful work is unique in the history of Portuguese art. Its uniqueness lies in the fact that it is unlike any previous school of work, and its style was not copied by subsequent artists.

The collection portrays the country from the fifteenth up to the nineteenth century, dealing with the cares and concerns of humanity, in pieces which varied from the illustrations of Biblical themes to the great fears of those who lived through the horror of the Inquisition. This can be seen in paintings such as *Inferno* - Hell, by an unknown fifteenth century master. It is the cruellest depiction of the nude in Portuguese art. The abundance of pieces with religious themes attests to the spending power of the Church, who commissioned them. There is also much foreign art along this theme, particularly by artists such as Albrecht Dürer and Hieronymous Bosch who painted the terrible nightmares of Santo Antão, the triptych of temptations, so rich in detail that something new can be found in it each time it is viewed.

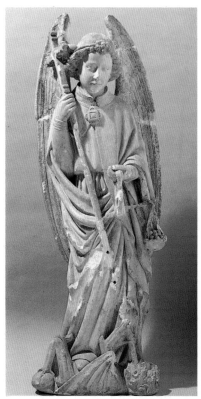

Archangel St. Michael (XV century), height 123 cm.

Fountain with anchor motif (XVI century), height 107 cm.

In the abundant collection of sculptures, the fifteenth-century so-called Malines images deserve special mention, small and doll-like wooden statues from the Netherlands.

The exhibition of Portuguese furniture covers a period of four hundred years, from the fifteenth to the nineteenth century. Of particular interest is the high backed chair which belonged to Afonso V, known as The African. It catches the attention, due to its unique presence and the venerable dignity which emanates from it. The Indo-portuguese pieces, inlaid with ebony and ivory, are also worth a special visit. In the old chapel of the Convento das Albertas is the enormous *Nativity Scene* made by Machado de Castro and José Barcos in the second half of the eighteenth century. The figures in it are of painted terracotta, set in cork and wood. The museum also contains two special rooms, one where the sculptures donated by Calouste Gulbenkian are exhibited. The sculptures include a beautiful Greek male torso, which dates from the fifth century B.C. The other is the Antenor Patiño room. He was a Bolivian multimillionaire who made his fortune ruthlessly operating tin mines. He wanted to add prestige to his name, and so bought the museum a complete room from the Paar Princes Palace in Vienna.

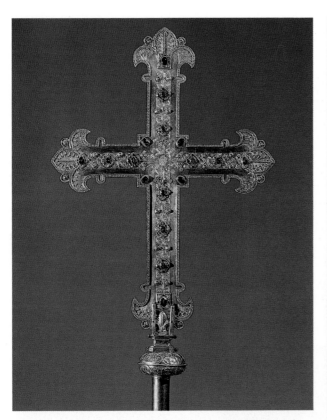

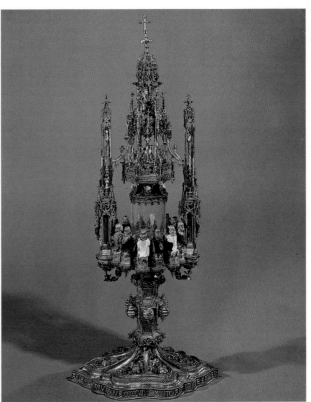

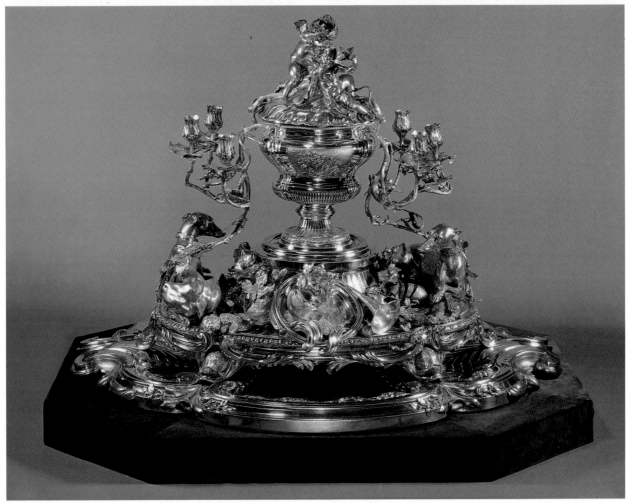

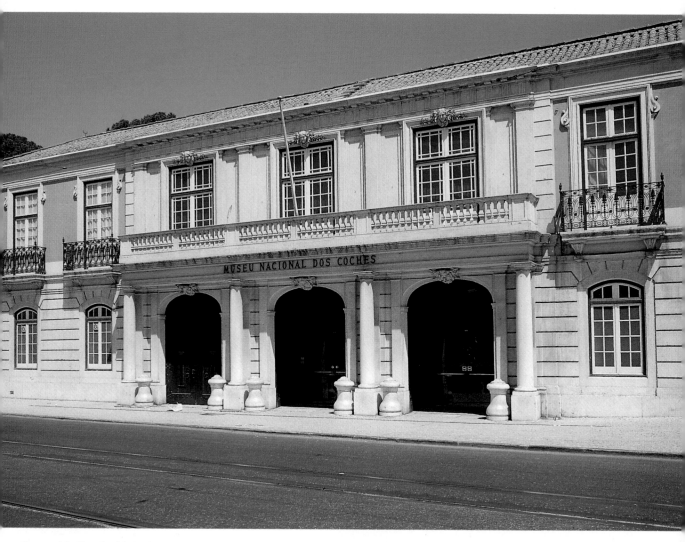

Cross of D. Sancho I (1214).

Belém Monstrance (1506) from the Mosteiro dos Jerónimos, height 83 cm.

Silver centrepiece (1756) by François T. Germain, 72,8 x 80,7 x 56,8 cm.

Façade of the Museu Nacional dos Coches, a former royal riding school built in 1726 on the east side of the Palácio de Belém.

MUSEU NACIONAL DOS COCHES

The **National Coach Museum** is housed in the former manege at Belém Palace. It was founded by Queen Amélia in 1905 and has become the best known museum in Portugal. In the spot where horses used to be exercised, there is now a fabulous hall filled with twenty of the museum's most important coaches and carriages, with a ceiling painted with scenes from classical mythology.

The oldest of the carriages was brought by Felipe II from Madrid to Lisbon in 1619. Also on display is the first coach to have gilded woodwork which was owned by Queen Maria Anna of Austria. However, even this is eclipsed by the coach given to João V by Pope Clement XI. This beautiful and famous coach was built in Paris in wonderfully pompous Baroque style, and its body fully glazed.

One of the most important pieces in the museum is another coach belonging to João V which was built in Lisbon in the first half of the eighteenth century. Its exceptional characteristics meant that it continued to be used - even after the death of the King - into the nineteenth century for grand and special occasions, such as

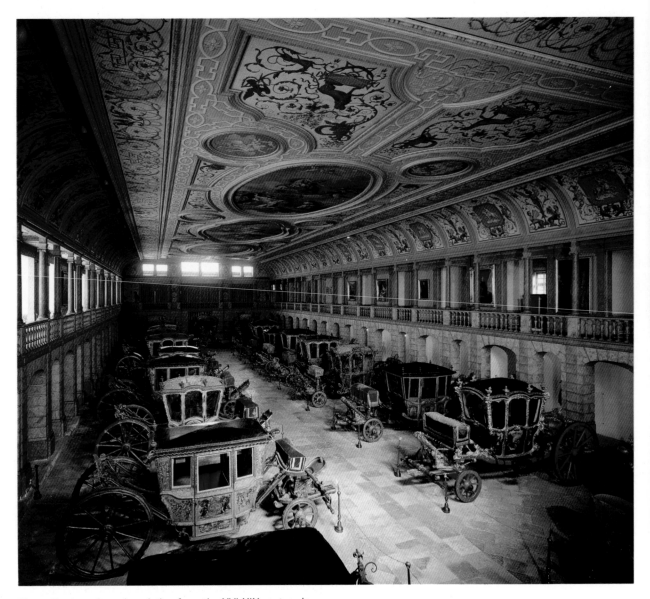

The collection of coaches dating from the XVI-XIX century is one of the most extensive of its type.

receiving kings and queens and other foreign dignitaries. At the back of the manege stand what remains of an example of the height of ostentation - three out of the eight carriages belonging to the embassy sent from Portugal as a demonstration of obedience to the Pope, which impressed the people of Italy in 1716.

In the exhibition in the side room, there are berlins, *coupés*, barouches and gigs. Of all the carriages, the "crown carriage" deserves special mention, together with that belonging to the Palhavã *meninos* - João V's illegiti-

mate children. Also of note are two processional berlins. Amongst the harnesses, litters and hunting horns, there are many interesting pieces. On the first floor, there is also a portrait gallery and a curious-looking figure. Solid and life-size, the figure represents a Moor. It is holding a shield and a whip and was used in the horsemen's games of skill. Queen Amélia is depicted smiling in a beautiful oval shaped portrait, and the small high-backed saddle and barouche of Prince Carlos of Portugal from when he was a child.

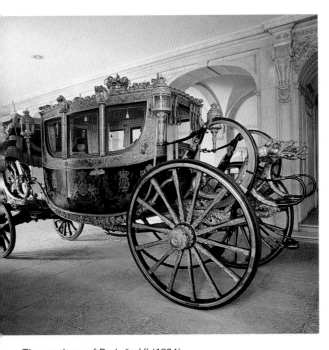

The carriage of D. João VI (1824).

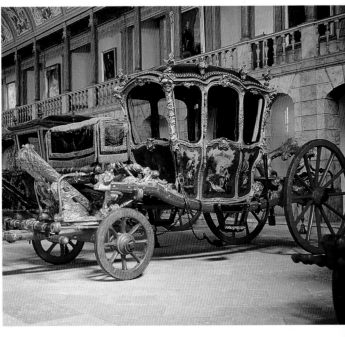

French gala carriage made for the Royal Family of Portugal
(mid XVIII c.).

Coach of D. José I (XVIII c.).

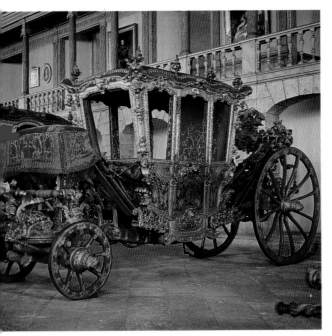

Gilded carriage of Maria Ana of Austria (XVIII c.).

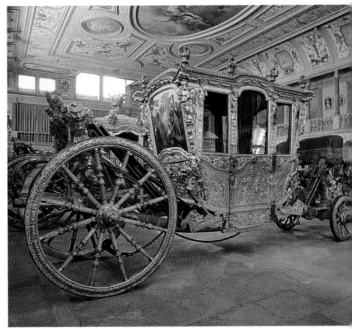

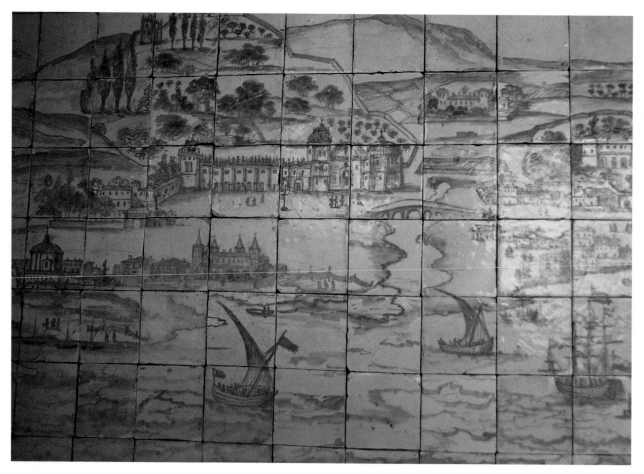

Mosteiro dos Jerónimos depicted on a tile panel before the earthquake of 1755.

Panoramic view of the Mosteiro dos Jerónimos (1502).

The former dormitory of the Hieronymite Convent houses the Museu Nacional de Arqueologia.

Following pages: the south side of the Igreja de Santa Maria and its octagonal cupola tower characterize the richly-decorated Manueline style of architecture; Nossa Senhora de Belém in the upper section of the magnificent south portal, a mass of gables, pinnacles and niches filled with statues.

MOSTEIRO DOS JERÓNIMOS

The fifteenth century ended gloriously for Portugal, thanks to the Discoveries. They meant that the country, as well as the rest of Europe which used Portugal as a gateway, was in reach of Africa and Asia by sea.

Near the spot where Vasco da Gama set sail for India in 1497, Manuel I built a monastery for Hieronymite monks in Belém, as a gesture of gratitude for the good fortune he envisaged for Portugal. These expectations were borne out the following century. Portugal became the centre of commerce in the Western world, which meant contact with the new known worlds, mainly in the Far East. The lands were now more accessible, and so their extremely expensive products were now more affordable.

At the beginning of the sixteenth century, in 1502, the first stone was laid for the *Monastery of St. Mary of Belém*, better known as the **Monastery of Jerónimos**. The sensation caused by the building is unforgettable

even today: this is considered the most glorious monument in Lisbon.

Building took several years, and was at first supervised by Boytac. The work of João de Castilho, who oversaw the second phase of construction, later made its mark, as well as that of the French sculptor Nicolas de Chanterenne. He introduced elements of the Italian Renaissance into Portugal, with clearly Lombardic medallions and chimeras. Mid century saw Diogo de Torralva presiding over construction. The sixteenth century building was concluded around 1571. The monastery later received alterations and additions without its splendour being in any way diminished by this.

It was mainly the interior which became successively grander over the centuries, through the addition of valuable works of art. In 1834, as a result of the liberal revolution, the religious orders were dissolved, and the huge collection of art was dispersed.

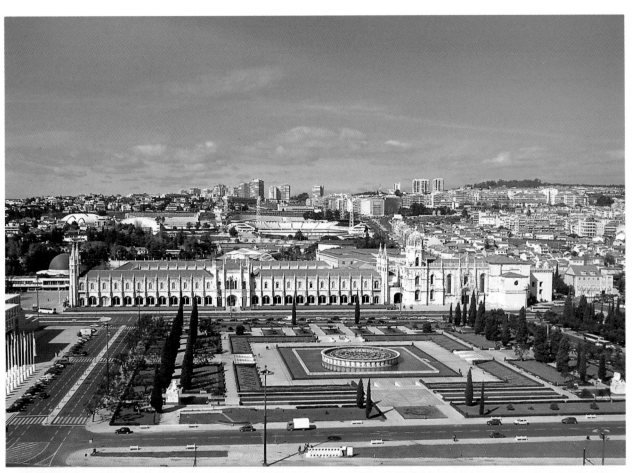

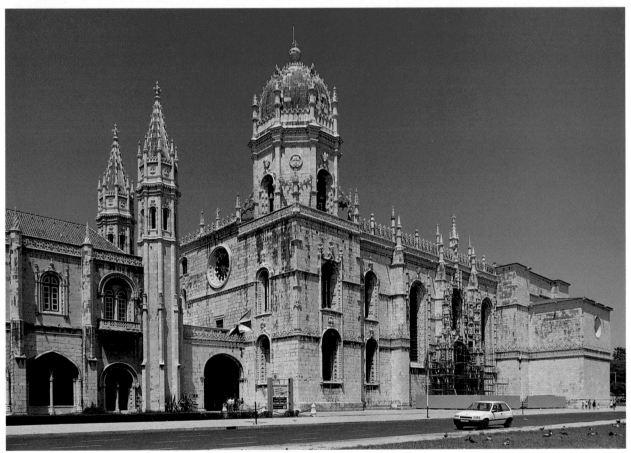

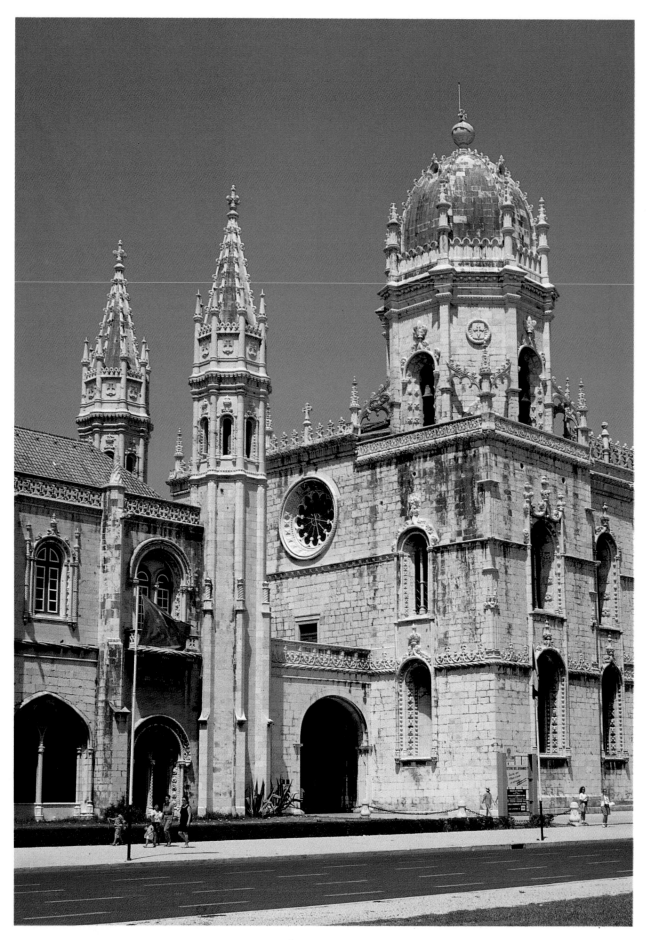

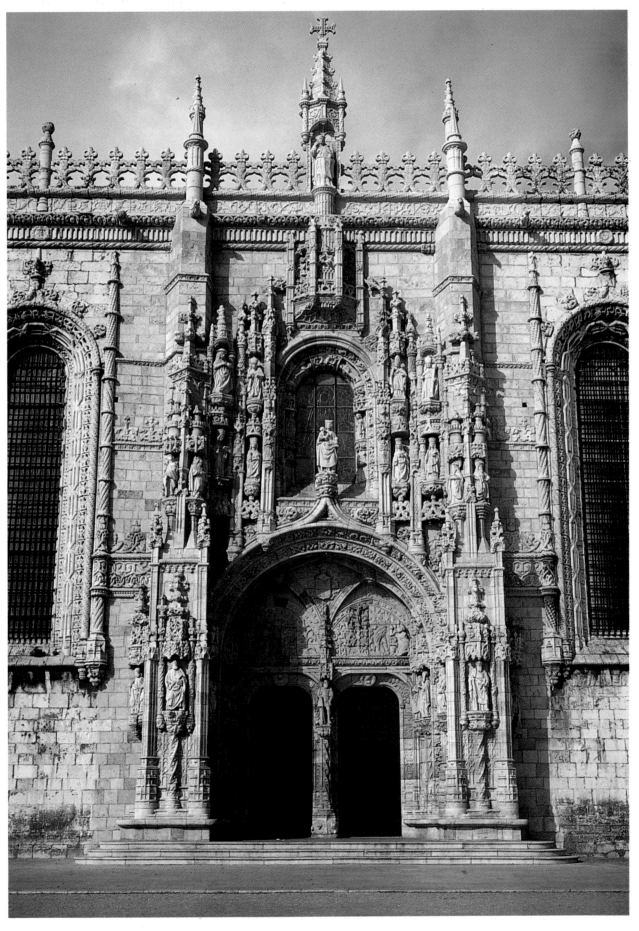

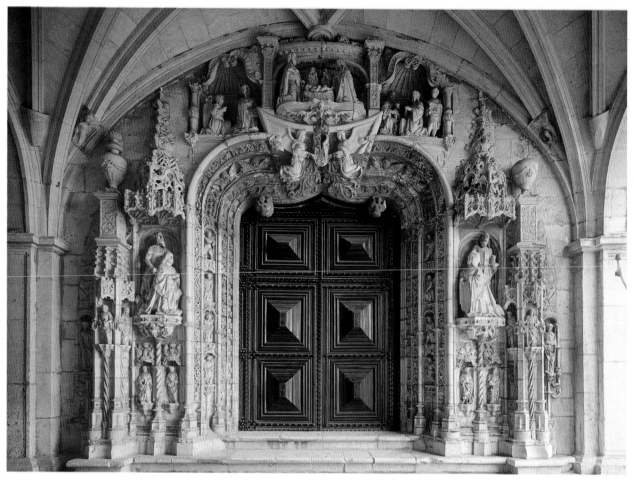

The west portal sheltered beneath the XIX century porch wich leads to the cloisters.

The vast transepts measuring 49 m across supported on delicately decorated octagonal pillars give an overall impression of spaciousness.

On the exterior of the building, the white stone is carved into pinnacles, rosettes, Gothic and Romanesque windows and other features of the Manueline style - cable-mouldings, armillary spheres, the Portuguese shield. There are also niches which contain life-size representations of Manuel I and Queen Maria Fernanda, kneeling, and protected by St. John the Baptist and St. Jerome. In the centre, the **west door** by Chanterenne clearly stands out. It is a seemingly never-ending design of relief, arms, emblems, niches and statues, such as that of Prince Henry the Navigator. Here he is represented differently from the conventional style which followed the St. Vincent de Fora Panels, currently in the National Museum of Ancient Art, as here his head is uncovered out of respect to the Virgin. Also to be seen are images of *Nossa Senhora de Belém*.

The **south doorway** is worth close attention - it features an image of Mary, surrounded by apostles, angels, Doctors of the church and saints, crowned by Africa and Asia.

Inside the church the nave and aisles are of identical height, separated by octagonal pillars. Their enormity and weight are disguised by de Castilho's decoration, which is so beautiful that you almost forget that they are there to support the building. Light filters in through the

stained glass windows, illuminating a limestone interior filled with tall columns. The lightness of design and effect belies the heaviness of stone. The ceiling is covered in arches which are an explosion of lines joined by jewels or flowers, also in stone. The cupola of the transept is the only one not supported by a column.

Whenever the door opens, light floods into the building, almost obliterating the reflections of the stained glass windows. When it is absolutely silent, you can make out a deep monotonous tone, which sounds like someone praying, but which is in fact the cooing of pigeons which nest outside.

Among the various chapels of the transept, after the Chapel of Baptism, is the Almeida Garrett Chapel. It was thus named on 9 December 1905, when Prince Luís laid a stone to mark the place where the novelist would be buried.

Beyond the wonderful carved pulpit is the **Chapel of St. Jerome**, with a representation of the saint by the famous Luca della Robbia. The main Chapel holds the tombs of Manuel I and Queen Maria, and João III and Queen Catarina. The latter is of Estremoz marble, and is supported by elephants carved out of whole blocks. Their tusks have the peculiarity of being made out of the first ivory to arrive in Portugal from India. Hanging over the

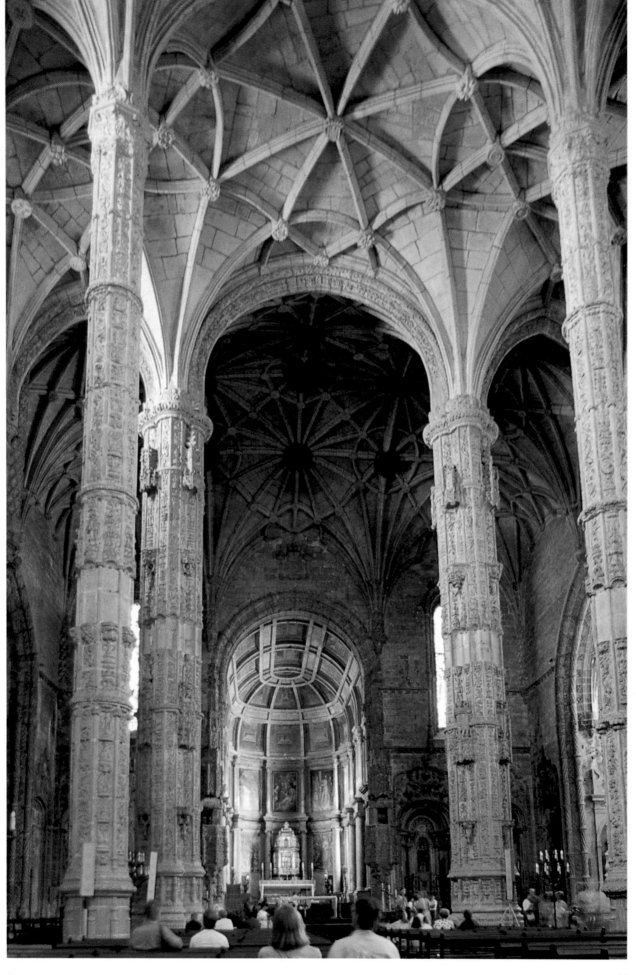

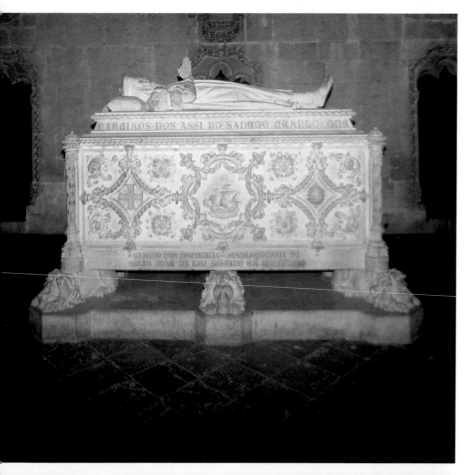

silver inlaid tabernacle are magnificent pictures given by the future king Pedro II. The gold work is by Gil Vicente who, in the sixteenth century, also created the famous **Belém Monstrance**, now in the National Museum of Ancient Art.

Opposite the Almeida Garrett Chapel are the tombs of Camões and Vasco da Gama, carved in 1894 to a design by Costa Mota. Also in the chapel are the graves of João III's children and the memorial to King Sebastian - the mythic Portuguese king defeated at Ksar-el-Kbir and who never returned. A statue of St. Gabriel, which Vasco da Gama took with him to India, stands by his cenotaph.

The chancel was built during the reign of João III and contains magnificent stalls, made around 1550 with renaissance artistic carpentry. A wonderful cupola floating high above the crossing, features the bronze shields of the caravels which voyaged to India and Brazil. The church follows the usual rhythm of rituals, and is also the scene for a special ceremony: the blessing of the university *students' ribbons* at the end of their courses, a time-honoured academic tradition.

The sacristy, which leads on to the cloister, is rich in architectural and pictorial treasures, such as the large treasure chest with sixteenth century paintings by Jerónimo de Ruão. The **cloister** itself has countless times been called the most beautiful in

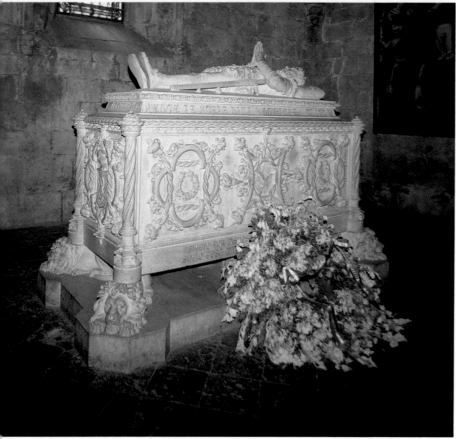

Tomb of Vasco da Gama (1469-1524), the first navigator to establish trading links with the Far East.

Tomb of Luis de Camões (1524-80), Portugal's great national poet.

The delicate system of ribbed vaulting over the nave and aisles.

The Upper Choir in the west gallery.

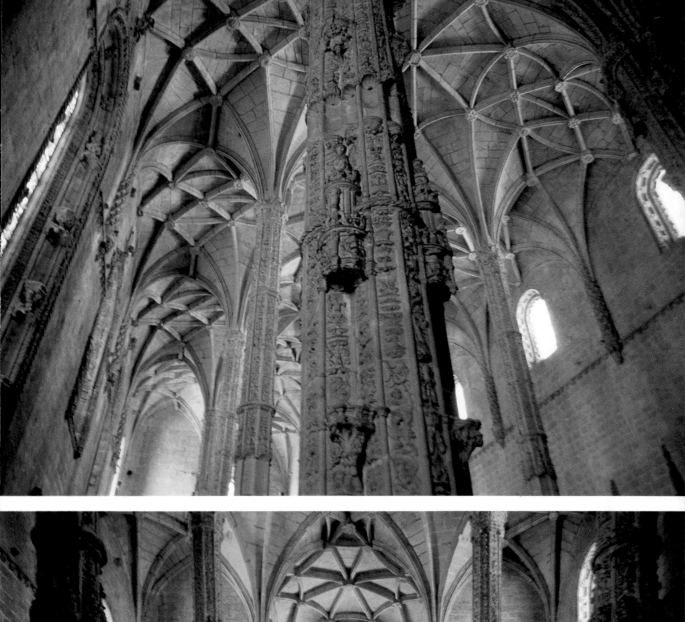
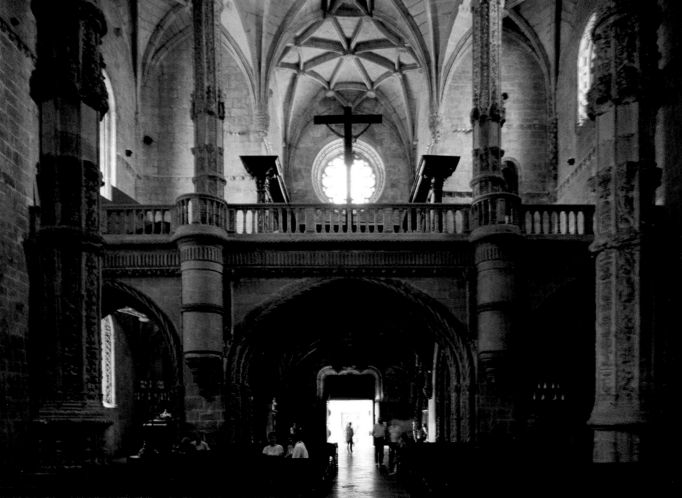

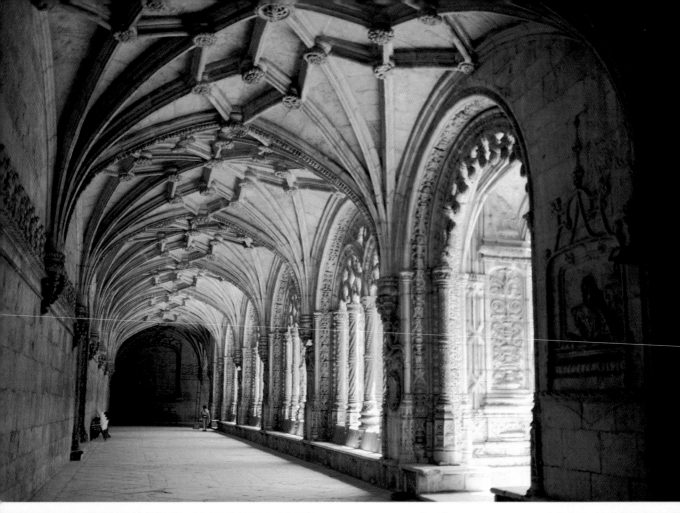

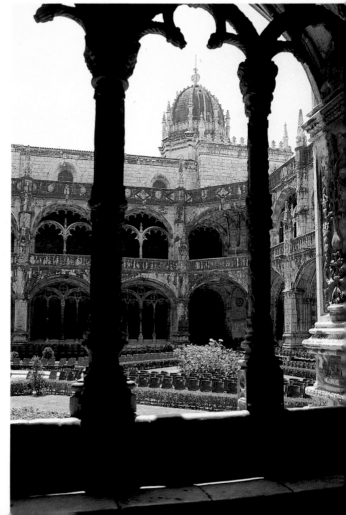

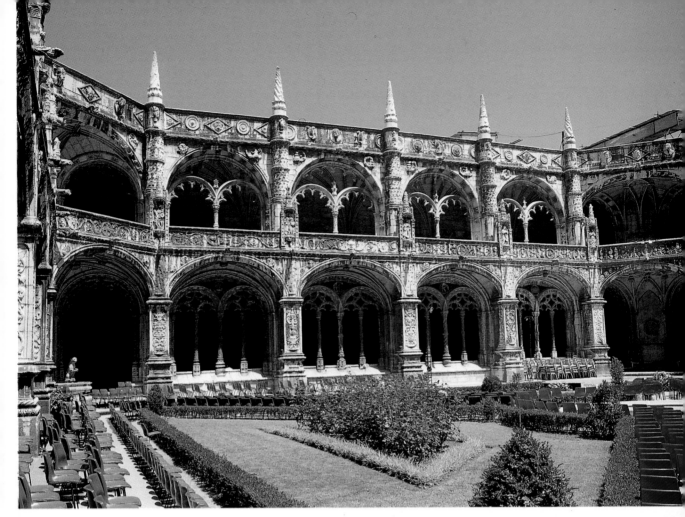

Ribbed vaulting at the ground level gallery of the cloister.

Lion Fountain in the north-west corner of the cloister garth.

Slender columns support the exuberant tracery.

The magnificent two-storey cloister with beautiful detail on every arch.

Canopies, columns and walls are profusely decorated with rich Manueline motifs.

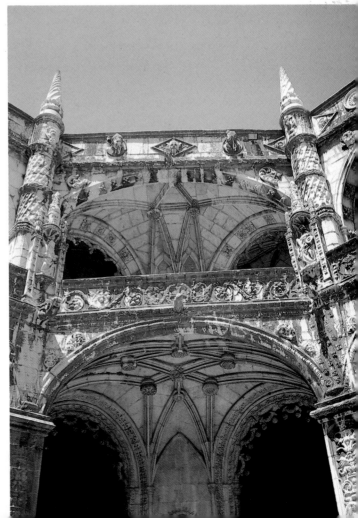

the world, and it is easy to see why. It has a serious, solemn air, not without a touch of fragility, a masterpiece of the flamboyant Gothic of sixteenth century architecture. The proportions are delicate, light and exuberant at the same time. Although the cloister was designed for peaceful reflection, a tournament did once take place here.

As in the interior of the church, lines grow out of the tops of the ornate columns, opening out on the ceiling like palm leaves, coming together into rosettes. Viewed from the central garth, in the north-west corner of which is a fountain with a stone lion, the lacy effect of the columns, pinnacles and other decoration is truly magical.

During the last few years this has been the setting for delightful summer concerts. The enormous monastery - which was declared a World Heritage site in 1983 - is big enough to house two well-known museums: the **National Museum of Archaeology** and the **Maritime Museum**.

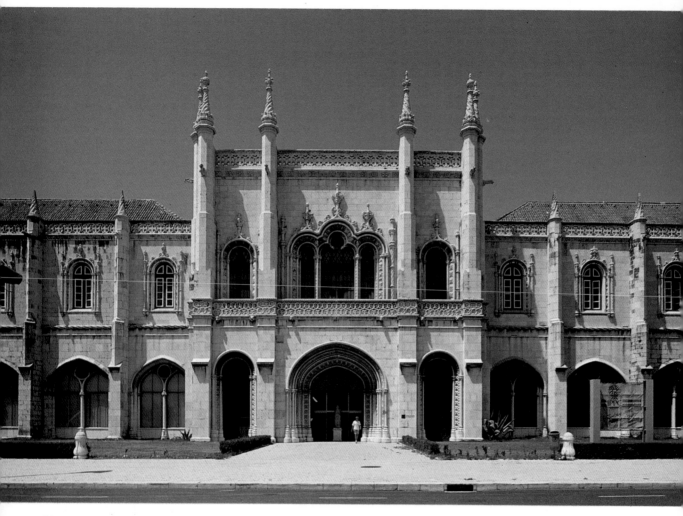

Museu Nacional de Arqueologia in the XIX century wing of the Mosteiro dos Jerónimos.

MUSEU NACIONAL DE ARQUEOLOGIA

The **National Archeological Museum** was founded in 1893 by Leite de Vasconcelos, and based on the antiquities collected by Estácio de Veiga. It was originally called the Ethnographic Museum, and was raised to the status of National Archaeological Museum in 1989. It is housed in the former dormitory of the Jerónimos Monastery, although it has moved twice, having been based in a room at the Geology Commission and, later, in the cloisters of the Lisbon Academy of Sciences. The museum boasts a rich and varied selection of exhibits.

The museum was first designed in two sections, archaeology and ethnology. These have been joined by others, including anthropology, epigraphy, numismatics and medals, together with comparative, island and overseas ethnology.

Ancient pottery and jewellery are also represented, with a particularly fine collection of ceramics, from handmade Stone Age ware, through medieval and Hispano-Arabic pieces, to the industrial manufacture of the nineteenth century. The museum also boasts priceless pieces in precious metals - earrings, rings, bracelets and necklaces.

Despite its wide-ranging collection, the museum has recently concentrated on archaeology. As a result, its collection in store and on display is of significant importance, both nationally and internationally. It possesses examples from both the Stone and Iron Ages, right through the centuries of Roman occupation and the Middle Ages. Some of the museum's most interesting work has been to illustrate trade routes in the stone age.

An important part of the collection deals with the Roman occupation of Portugal, with mosaics, statues, milestones, instruments and tools of every kind. The museum also devotes space to the livelihoods and crafts of the time. There is also an Egyptian section, with the only three mummies in Portugal.

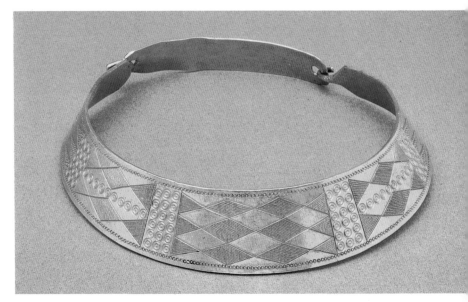

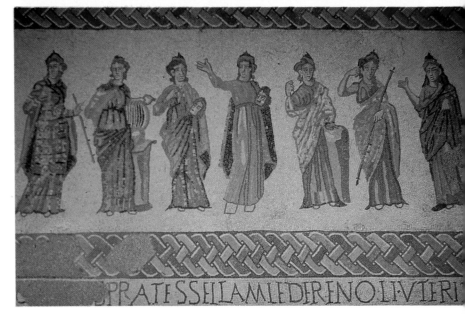

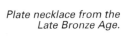

Roman amphoras (IV c. AD)
from Tróia (Setúbal).

Lusitanian warrior, Iron Age.

Plate necklace from the
Late Bronze Age.

Sarcophagus of a girl,
III century of the Roman era.

The Muses panel, III c. AD
mosaic, 241 cm.

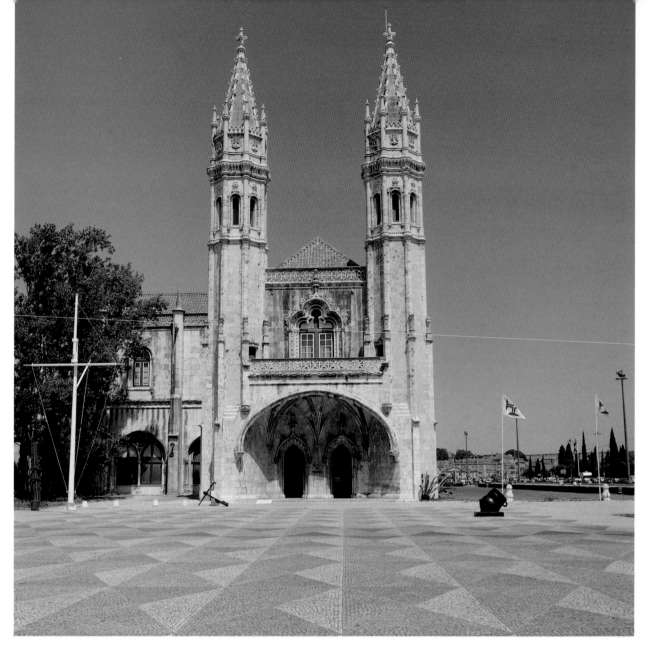

The main section of the Museu de Marinha is housed in the Western wing of the Mosteiro dos Jerónimos.

MUSEU DE MARINHA

Currently housed in a wing of the Jerónimos monastery, the **Maritime Museum** was founded in 1863 in very different surroundings. King Luís had two aims in founding the museum: firstly to give a home to the remaining documents recording Portugal's maritime history. Alas, the best of the historical records had been destroyed in the earthquake of 1755 or carried off during the Napoleonic invasions. His second aim was to offer an inspiration to future naval officers. For this reason the museum was first housed at the Navy College, at that time in the Lisbon Arsenal, where it remained until a fire in 1916 destroyed much of its collection.

Happily, history did a volte-face in 1948. Unhappily, it came about thanks to a sad event - the death of the col-

lector Henrique Manfroy de Seixas. He donated his collection to the museum, enriching it considerably. In the same year, the museum was transferred to the Palácio das Laranjeiras. However, it was only in 1962, when it moved again to a wing in the Jerónimos monastery, that the exhibition got the dignity it deserved. Models, original maps and charts, photographs, uniforms, paintings, medals, figure heads, weapons and other examples of nautical art were finally able to breathe.

The majority of the models come from the Seixas collection, and illustrate the development of ship building. They cover a considerable period of time, from the ancient Egyptian boats, made of papyrus, up to the most modern vessels - warships as well as merchant ships.

General view of the Discoveries Room.

Wooden statue of the Archangel St. Raphael.

*Replica of the Ielala Rock in Zaire with inscriptions
ordered by the navigator Diogo Cão (1483).*

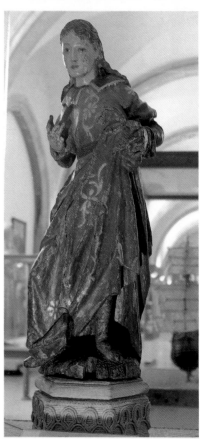

Portuguese traditional fishing is also represented by a collection of boats which are practically unique. The models of the royal brigantines are also of note, as are the warships and caravels of the Discoveries, which were made in the Museum workshops to designs by Gago Coutinho and Quirino da Fonseca. Of these, the warship Príncipe da Beira deserves special mention, not only for its elegant style, but also for its detail. Also worthy of attention are the actual cabins of the royal yacht which belonged to Carlos I and Queen Amélia.

Among the examples of contact between the Western and Eastern civilisations are pieces from Japan. The merchant navy is also well represented in the museum. The exterior gallery houses some examples from Portugal's various mainland and island regions. Amongst other things are a whaling boat from the Azores and boats from Costa da Caparica, with the *eye of God* painted onto

The royal quarters from the yacht Amélia, preserved after the ship was dismantled in 1938.

the bow. After comes the **Galliot Pavilion**, which was specially built to exhibit this kind of vessel. The royal galliots are particularly splendid, and the oldest dates from 1724. The most impressive vessel there is the *Royal Brig*, dating from 1778 from the reign of Maria I. The design is by Torcato José Clavine, and the vessel had a crew of eighty oarsmen. The magnificent stern is covered in gilt carvings with the royal coat-of-arms surrounded by feminine and mythological figures, and the vessel still boasts the lovely canopy by Pedro Alexandrino.

Next in line is the first hydroplane to be used by the Navy and the most famous flying machine in Portugal's history, a *Fairy 17*, called Santa Cruz. This plane took Gago Coutinho and Sacadura Cabral on the first flight across the South Atlantic in 1922. For longer journeys, the neighbouring Calouste Gulbenkian Planetarium takes you around the universe.

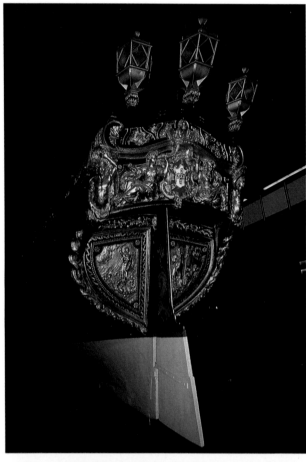

Gilded stern of the Royal Brig (1778) built for Queen Maria I.

The Large Barge (1711) was manned by 80 oarsmen.

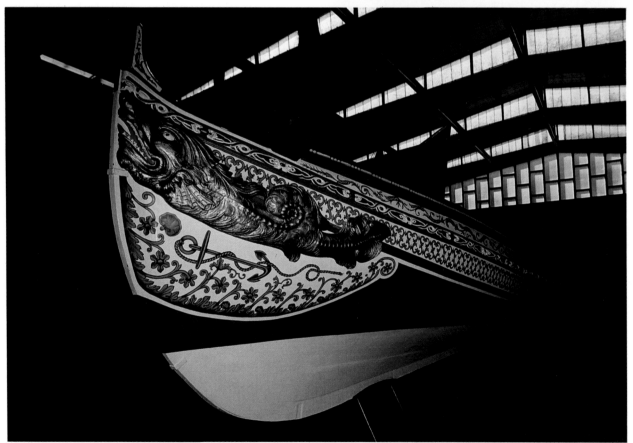

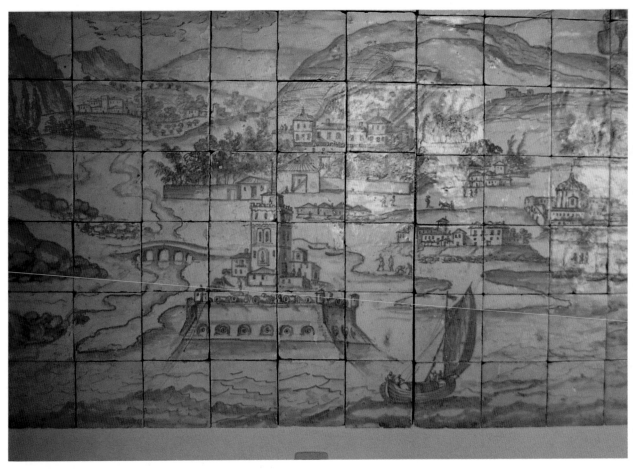

Torre de Belém depicted on a tile panel before the earthquake of 1755.

Torre de Belém, a remarkable example of Manueline architecture.

TORRE DE BELÉM

A symbol of Lisbon, the tower is easily the best known of the city's monuments, both in and outside Portugal, but it has not served its original purpose for many years. The idea to build it came from João II, and he commissioned Garcia de Resende. However, it was only completed after his death, twenty years later during the reign of his successor, King Manuel, to a design by Francisco de Arruda. He belonged to the remarkable family of architects who served the Aviz dynasty for four generations. He was also a specialist in military constructions, examples of which had already been built in the Alentejo and Morocco.

The tower is square-shaped and surrounded by open walls forming a platform, which point it out towards the sea like a ship. The facade looking out onto the river over the crenel-carved platform gives the tower its nautical air. Although the tower was not built for aesthetic purposes - its main aim was to protect the Tagus and the city - its decoration is quite exquisite, not at all like traditional fortresses, with delicate carvings in limestone.

Work began in 1515 and was concluded in 1521. The tower was also known as the Fortress of St. Vincent, as King Manuel had put it under the protection of Lisbon's patron saint, and at that time it was completely surrounded by water. However, the river receded and it now stands on the shores of the Tagus. A few years ago, it was protected from strong tides by a structure which leaves only a ribbon of water around it. The tower is one of Lisbon's most impressive monuments, bringing to mind the Portuguese colonial empire. It was built on Restelo beach on the Discoveries Quay. Its walls bear pinnacles and beautiful carvings, as well as other decoration typical of the Manueline style, such as cable mouldings, knots and armillary spheres. On the narrow balcony, there is a niche containing **Nossa Senhora da Boa Viagem**. Its well-proportioned design reflects both Romanesque and Gothic styles, in the arched doorways and the arcades. Other styles are also present, as in the Byzantine domes, and the Venetian balconies, as well as details influenced by Mauritanian art, via Morocco. Worthy of note is the first European sculpture of a rhinoceros, to be found on the northeast corner of the tower.

Compared to the lavish facades, the **interior** is sober,

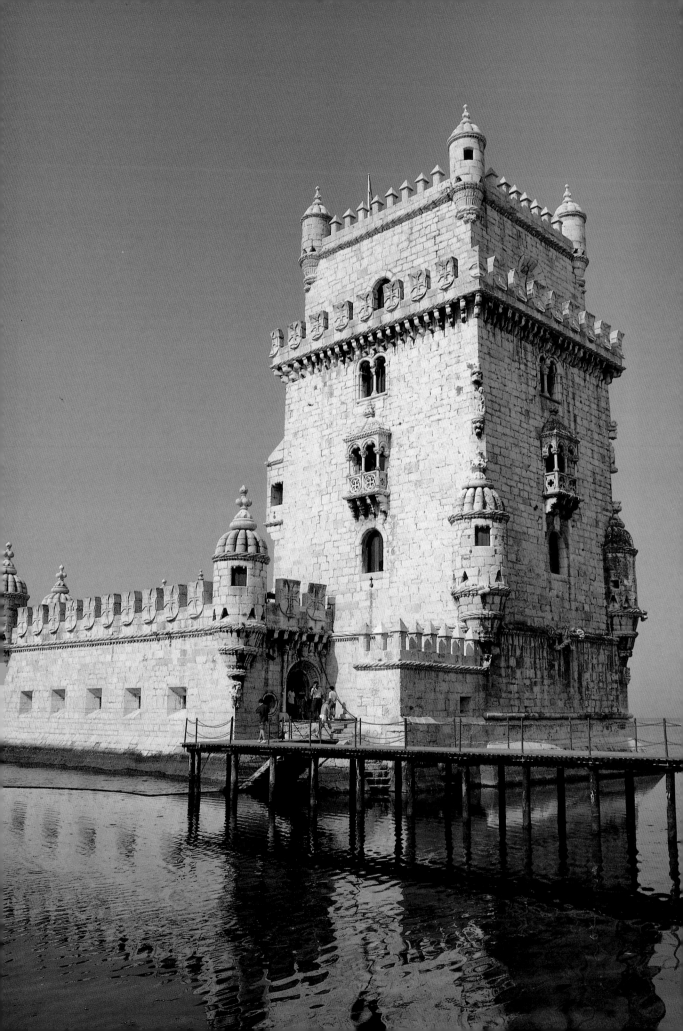

even austere. Access is gained through a passage leading from the drawbridge. On the lower floor are five cells which are reached by descending 35 steps. The cells were originally used for gunpowder storage before they were occupied at several stages by political prisoners. On the ground floor is the terrace where the cannons were kept.

Next are the floors housing the Armoury and the Royal room, the latter endowed with a wide balcony with beautifully sculpted columns. Above this was the refectory. On the outside, you can still see the holes used to pour molten lead over potential assailants. On the fifth floor, designed for royal residence, is a plaque commemorating the first flight from Lisbon to Rio de Janeiro by Gago Coutinho and Sacadura Cabral in 1922.

Another 123 steps lead to the top floor, another terrace with a magnificent view. The number of steps, crenels, floors and the measurements of the tower obey a symbolic concept. Nothing was left to chance in the tower which not only protected the city, but also bestowed blessings on the sailors, so they would return and enrich

Gothic statue of Nossa Senhora da Boa Viagem inside the richly-decorated baldachin of the bastion.

Pinnacles and pillars on the inner wall of the bastion.

The main façade is turned towards the Tagus.

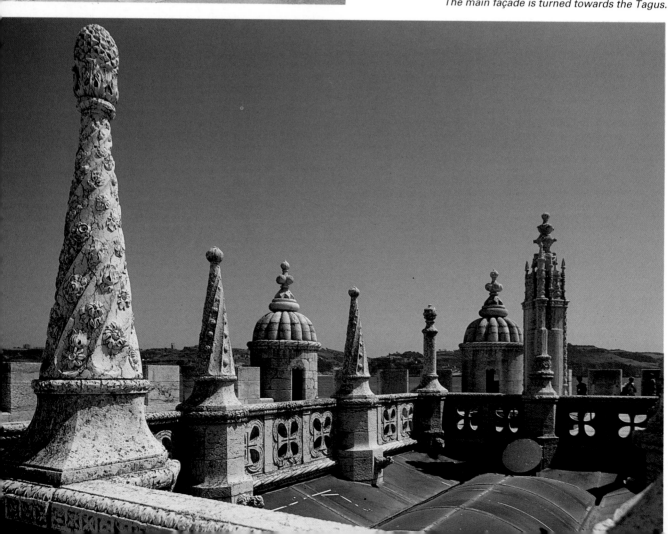

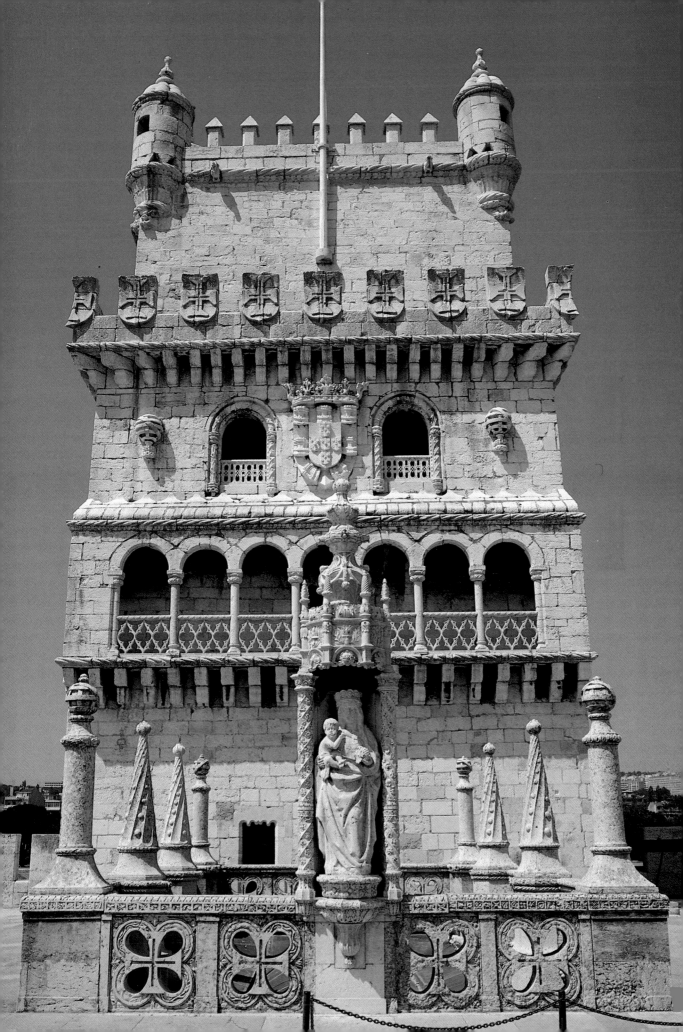

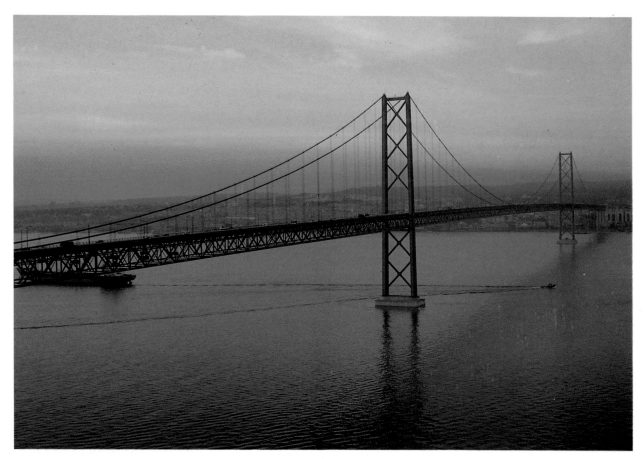

The austere interior of Sala da Nave and Sala das Reuniões contrasts sharply with the profusely decorated exterior.

Ponte 25 de Abril (1966).

the kingdom with the precious merchandise brought from all over the world.

As the tower is so obviously beautiful, it is hard to believe that it was in danger of not surviving last century, owing to neglect. Next to it had been built a gas generator belonging to the lighting company. Its chimney belched out all kinds of polluting gas all over the tower. After the closure of the gas company and some restoration work in the nineteen fifties, the tower regained its deserved dignity. More restoration work was carried out in the eighties during the preparations to be one of the five centres of the seventeenth Exhibition of European Art, Science and Culture: Armoury from the fifteenth to the seventeenth century.

Visits to the river and the tower, which now houses art exhibitions and seminars on a range of themes, are not complete without stopping off at one of Lisbon's most famous pastry shops. Located halfway between the Monastery of Jerónimos and the National Coach Museum, the cake shop has for nearly a century been making the famous *pastéis de Belém* - Belém tarts. They are dusted with icing sugar, and lots of cinnamon - one of the many products brought back from the far East, now firmly fixed in the history of the quay at Belém.

MONUMENT TO THE DISCOVERIES 25TH OF APRIL BRIDGE CRISTO-REI

The **Monument to the Discoveries** was built for the Exhibition of the Portuguese World, in 1940. However, the existing monument is not the original, which was destroyed in the cyclone that hit Lisbon in February 1941, but a replica.

On the ground beside the monument lies a giant mariner's compass, a gift from South Africa on the five hundredth anniversary of the death of Prince Henry the Navigator, the founder of the school of Sagres. A statue of the Prince holding a caravel makes up the front of the monument. Behind him are cartographers, mathematicians, astronomers, carpenters, cordwainers, shield bearers, pilots, captains, doctors, zoologists, missionaries, chroniclers - all those that took part in the epic of the Discoveries. From the top of the monument there is a fantastic view of the city, as well as the southern bank of the Tagus.

The **25th of April Bridge** rises above Alcântara and

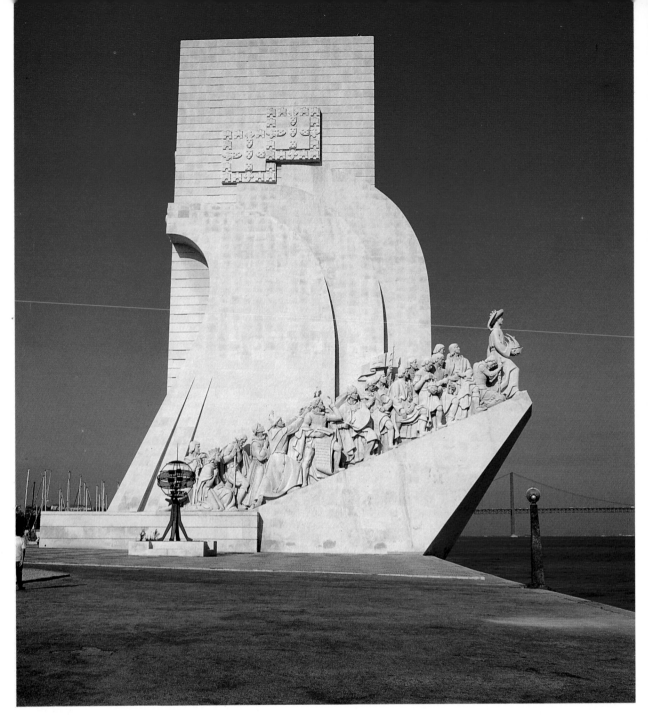

Padrão dos Descobrimentos (1960).

heads south across the river. Completed in 1966, it is currently the only bridge across the Tagus this close to Lisbon. This elegant structure, which is nearly two and a half kilometres long and sixty metres high, is used daily by thousands of commuters.

The sanctuary of **Christ the King** stands opposite the bridge and above the city of Almada. As old as Lisbon, this was a place of refuge for many nobles from the city when the capital was laid waste by the plague. The sanctuary is also near the place where Fernão Mendes Pinto died (he was the first Westerner to reach Japan). The monument was built by Salazar to give thanks for Portugal not being involved in the Second World War.

The statue is a smaller scale replica of the monument of Christ on Corcovado hill in Rio de Janeiro, and was completed in 1959. It is 109 metres high, 81 of which make up the pedestal, and the remaining 28 the statue. The monument faces north and was the work of two sculptors: the statue with the shape of a heart sculpted onto the chest was by Francisco Franco, and the rest was by António Lino.

Christ the King towers over the Tagus and overlooks the whole estuary, as far as Arrábida in the south and Sintra in the north. Lisbon's pale beauty can be seen reflected in the green waters of the river - Camões' "liquid emerald".

MUSEU NACIONAL DE ETNOLOGIA

The **National Ethnology Museum** grew from a collection of pieces brought back by Portuguese travellers from the sixteenth century onwards. It exhibits works representing different peoples and cultures, and was conceived along completely different lines from other ethnological museums and the majority of museums in general. After hundreds of years of unsystematically acquiring pieces, a small group of researchers created the *Mission for Ethnic Minorities from Overseas Provinces* which, despite its name, had wide ranging objectives. Although the first work carried out by the group was aimed at the then Portuguese colonies, the over-riding objective was to collect examples of ethnic art.

The first exhibition, *Life and Art of the Maconde People*, opened in February 1959, and this led again to the idea of creating an ethnological museum along universalist lines. This would mean that objects would be collected as a consequence of studies, and not the other way round. The emphasis was therefore given to human adventure, as the pieces collected were simple elements that illustrated life and culture of different peoples. Work carried out made it possible to collect an enormous number of objects, so varied that there was something from every continent.

The *Museum of Ethnology of the Overseas Provinces* was created in 1965, although its name was changed after 25 April 1974 to the Ethnology Museum. In 1975, the museum was located in a purpose-built building in Belém. It has been a national museum since 1989, and its cultural and scientific mission is still one of the most open and stimulating.

Wooden Careto-Mask from Trás-os-Montes (Bragança).

Wooden statue of a Quioco chief from Angola.

Cara-Grande Mask from Brazil.

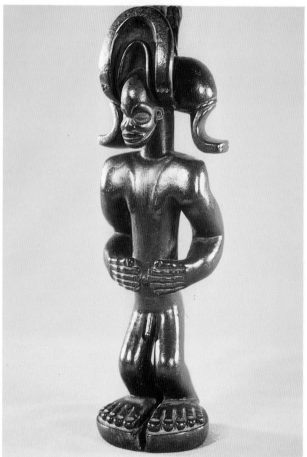

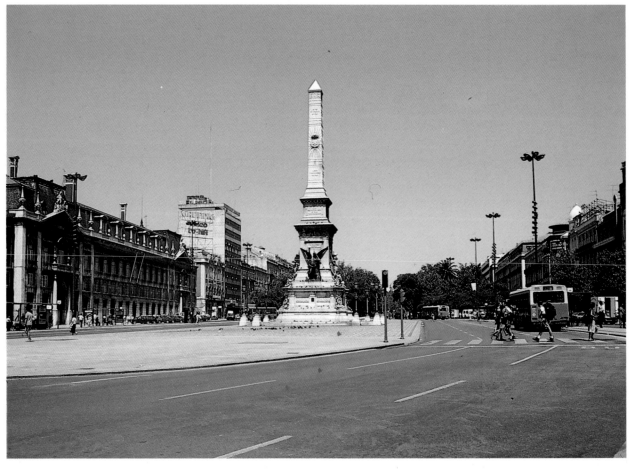

The Monumento dos Restauradores (1886), a 30 m tall obelisk stands in the centre of the Praça dos Restauradores.

The Praça and Memorial (1934) to the Marquês de Pombal.

PRAÇA DOS RESTAURADORES

In 1886, in Praça dos Restauradores an obelisk was inaugurated to commemorate the Restoration of Independence, which on 1 December 1640, put an end to the sixty years of Spanish domination. The northern end of Restauradores opens into Avenida da Liberdade, and the southern gives on to Rossio, and the neo-Manueline railway station with the same name. The station is the terminal for the Sintra line, and was built to a design by José Luís Monteiro. Also in Restauradores is the former Éden Theatre, built by the architect Cassiano Branco in 1937, which has been converted into a hotel and shopping mall. Its neighbour, Palácio Foz, started in 1755 by Fabri, was the headquarters of the propaganda machine of the so-called New State. After 25 April 1974, it housed the State Department for the Media, as well as the tourist office. Slightly further down, next to Rossio station, the neo-classical Avenida Palace Hotel - also by Monteiro - reminds one of times gone by.

AVENIDA DA LIBERDADE

Less than ten years after the earthquake shook Lisbon, the architect Reinaldo Manuel was commissioned to design a public promenade. It was to be built in the area known as Hortas da Cera, between Restauradores and Praça da Alegria.
The avenue rapidly became a centre of amusement for

nineteenth-century inhabitants of the city and the place to be seen for members of high society. There was great protest at the plan to replace the promenade with a larger road extending northwards. However, José Gregório Rosa Araújo, leader of the Municipal Council between 1878 and 1885, was devoted to the city's progress. He ignored the protests and built Avenida da Liberdade, the widest avenue in Lisbon. The first section was opened in 1882.

The creation of Edward VII park in 1885 frustrated plans to extend the avenue to Monsanto, and it remained very much in its present form, from Restauradores to Rotunda, 1,500 metres long and 90 metres wide.

The avenue consists of a wide central road and two narrower side roads, separated by paved areas. Each of the different paved sections is lined with trees, such as elms, sycamores, Judas trees, lotus, acacias, palm trees and mulberry trees from China. The avenue also contains several statues, mainly of writers, and beautiful mosaic pavements.

Nowadays, Avenida da Liberdade has three pavement cafés and several cinemas, and has also had many new buildings constructed. However, it still boasts many interesting structures, such as the Old Hotel Vitória and the Diário de Notícias building.

PRAÇA MARQUÊS DE POMBAL

At the top of Avenida da Liberdade, at the other end from Restauradores, is Praça Marquês de Pombal. This large traffic circus, also known as Rotunda, lies at the bottom of Edward VII park. Built between 1917 and 1934, it is paved in the traditional mosaic pattern. Six of the city's arterial roads which extend over almost the whole of the capital, converge on this central roundabout. Below street level, there is a tube station, which gives access to all destinations on the underground system.

The roundabout is dominated by a south-facing 36-metre-high monument to José I's famous Prime Minister. The massive pedestal looks towards a Lisbon which victoriously survived the earthquake. On one side, it features the mythical figure of Minerva, and on the other, representations of Agriculture and Industry. The Marquês, in pensive mood, is accompanied by a lion - a symbol of royalty. It was at Rotunda, and the area surrounding it, that many of the revolutionaries who established the Republic on 5 October 1910 mustered forces.

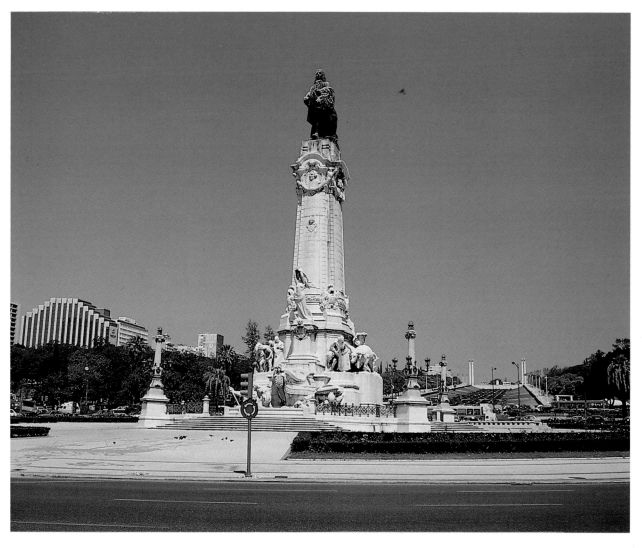

The view from the upper end of Parque Eduardo VII.

Estufa Fria (1929) in the north-west corner of the park.

EDWARD VII PARK

Edward VII Park is relatively new. Until the end of the 1920s, the area was a stony plot of wasteland where children used to play. As the city grew, the new avenues became more and more important and so this expanse of land was earmarked as a potential green area. The park was created and given the name Edward VII, in honour of the English king who visited Lisbon in 1902.

In spite of the constant bustle of the city, this green space is still a peaceful oasis, with lakes and countless species of trees. In June, the rosewood trees are covered in violet blooms. The park contains two greenhouses - one of them heated - that remind you of other faraway places. Exhibitions are frequently held there, as well as antique fairs, fashion parades and concerts. During the months of May and June, a well-attended book fair is held on the paths either side of the lawn.

The park is situated between luxury hotels, the *Penitenciária,* or prison, the Palace of Justice and the **Carlos Lopes Sports Centre**, and at weekends it serve as the meeting point for many people from the provinces who work in Lisbon. People from one area group together, and sometimes they sing and perform traditional dancing.

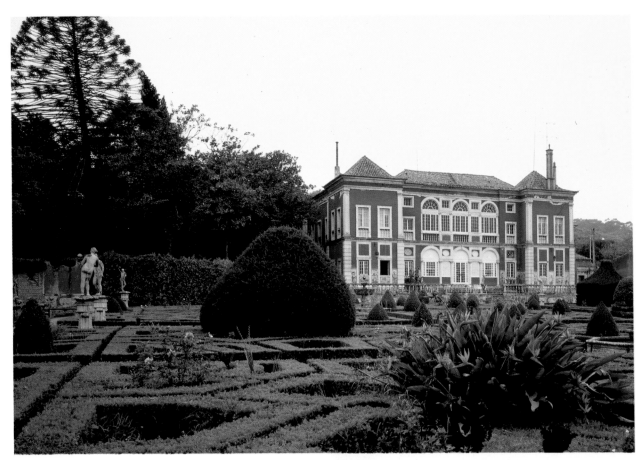

Palácio Fronteira and the Formal Garden.

The Kings' Gallery.

THE FRONTEIRA PALACE

Noteworthy for its range of tile decoration, the Fronteira Palace São Domingos de Benfica was built between 1650 and 1675 by order of Dom João de Mascarenhas, the first Marquis of Fronteira. In 1765, ten years after the Great Earthquake, the original design was added to and the decoration enriched. The present buildings date from this period and include the palace itself and the park and gardens replete with statuary, which have been described as the best Portuguese example of the Renaissance Style.

Worthy of special attention are the Great Lake, the Gallery of the Kings, the terrace with its pyramid-topped turrets on either side and the panels of *azulejos* with equestrian figures representing members of the Mascarenhas family.

Inside, the main features are the Battle Room with its seventeenth century *azulejos*, showing scenes from the War of Restoration and the Panel Room with *azulejos* from the eighteenth century, fresco painted medallions and oil paintings by Pellegrini and Sequeira. The Dining Room is also graced by the work of a well-known artist - Pedro Alexandrino - who was responsible for the eighteenth-century decoration.

Together the Palace and Gardens make up an iconographical nucleus which is rightly considered to be one of the most important of the Restoration period.

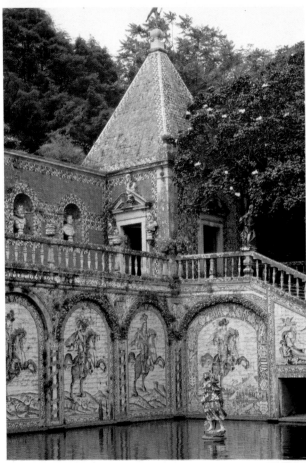

CALOUSTE GULBENKIAN MUSEUM

The Armenian business man, Calouste Gulbenkian, was born in Turkey in 1869. A philanthropist and patron of the arts, he was generally known as Mr. Five per cent, after the commission he charged the oil companies, which he used to set up a huge fortune and invest in carefully chosen works of art.

In spite of having taken British nationality, he divided his time between London, Paris and the Gulf. He preferred eighteenth century French art, and collected it avidly. He also collected Middle and Far Eastern art, especially Islamic, and owned an impressive collection of masterpieces. However, his interest was not limited to ancient art - in Paris, he was a friend of René Lalique and did much to encourage him at the beginning of his career. After 1942, he moved to Lisbon and stayed here until his death on 20 September 1955. He left a great deal of his collection to the Portuguese State, as a token of his "esteem and friendship", this on top of donations he had made during his lifetime to the National Museum of Ancient Art. Furthermore, around two years earlier, he had created a Lisbon-based foundation, whose object it was to support the arts, culture, scientific research and vocational training. The Calouste Gulbenkian Foundation opened the doors of its extremely modern buildings in 1969, right in the heart of Lisbon, and soon became a centre for the arts.

French silverware (XVIII-XIX c.).

French decorative arts (XVIII c.).

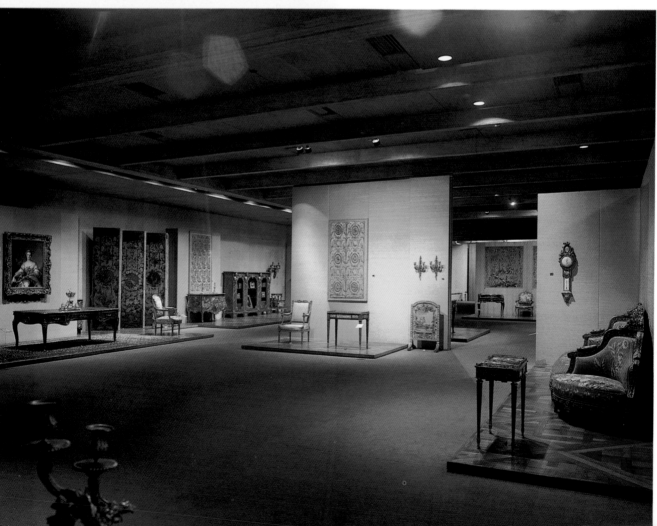

Past Gulbenkian's statue, which sits under the protective shade of a falcon, are the beautiful, welcoming gardens which surround the buildings. This, the headquarters of the foundation, has expert staff, a library specialising in the History of Art, many different rooms and halls used for meetings, film shows and live entertainment. It also has an open air auditorium, space for temporary exhibitions and two museums. One, named after its benefactor, is dedicated to ancient art, and the other houses the **Modern Art Centre**.

The Gulbenkian Museum was created to exhibit the beautiful objects with which its founder surrounded himself. He wanted them to be within reach of the public, and the museum is one of the few to be built from scratch specifically for this purpose. The pieces are given breathing space in rooms which are spacious and unfussy, thus obeying the most modern standards of museum layouts. It houses a collection of 3,000 works of art covering around four thousand years, from Egyptian civilisation to the beginning of the twentieth century.

At the entrance to each room, there is a helpful and easy-to-understand written guide to the exhibits. Everything is covered, from sculpture to faience, as well as ceramic tile art, tapestry, and glassware. A trail leads from the Middle and the Far East, by way of lacquers, marbles and porcelains to Europe, with its eighteenth century French furniture, Grand master paintings and sculpture by Manet, Degas, Renoir, Rembrandt, Rubens, Rodin and many others. No piece is positioned by

Lady Henut Taoui, *Egypt, New Kingdom, XVIII Dynasty, polychrome wood and goldleaf, height 29.2 cm.*

Deep plate (XVI c.), Turkey, Iznik faience; diametre 35.5 cm.

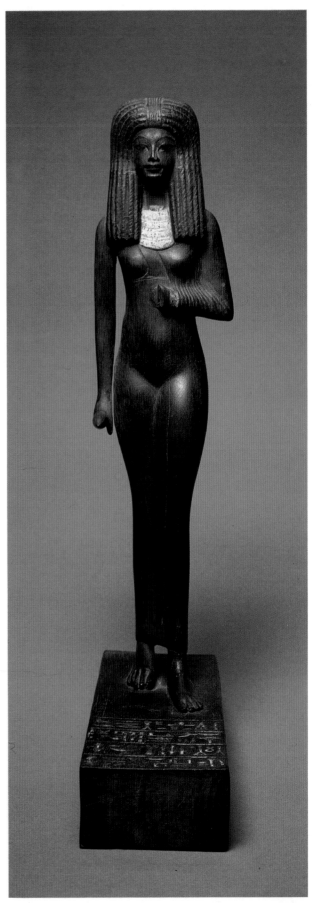

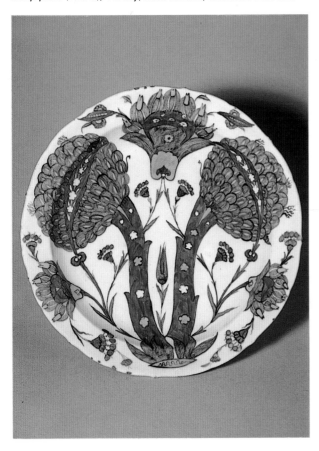

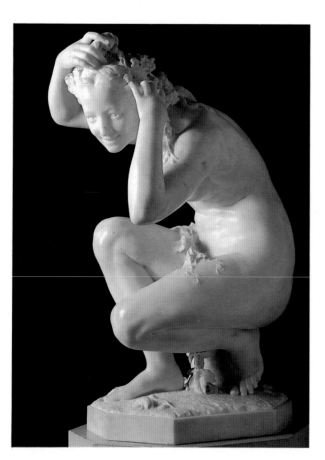

chance, neither does the public feel overwhelmed by the magnificence of the exhibits. The Lalique collection is one of the most famous in the museum as it is one of the most complete on a world scale, and has a room to itself.

The Modern Art Centre was created in 1983 and is now one of the mainstays of Lisbon's cultural scene, thanks to its many exhibits and artistic activities, which mainly come under the heading of dramatic and musical. It houses a museum, a documentation centre, experimental workshops, exhibition and projection rooms, a multi-purpose hall and a restaurant.

On summer evenings, the auditorium in the gardens plays host to music and dance, both classical and modern - the Foundation company specialises in the latter. The month of August is dedicated to jazz, played in the open air. Together with other organisations, the Foundation also organises classical music events all over Portugal. Its valuable cultural contribution goes further still - it publishes Portuguese and foreign work in the areas of the sciences and the arts, as well as promoting the pleasure of reading, through its mobile libraries. Not to be forgotten is the important work the Foundation does in other areas, such as supporting research and specialised training, social security organisations and most recently, the Portuguese-speaking African countries.

Flora (1873) by Jean-Baptiste Carpeaux (1827-75), marble, height 97xwidth 65xdepth 60 cm.

The feast of the Ascension on Piazza San Marco by Francesco Guardi (1712-93), oil on canvas, 61x91 cm.

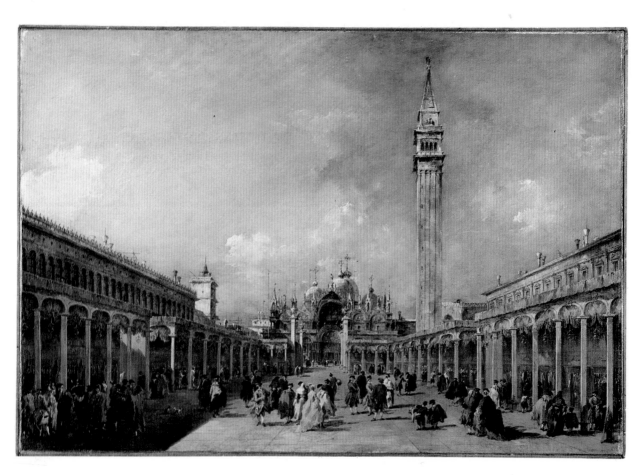

Boy blowing bubbles *by Édouard Manet (1832-83), oil on canvas 100.5x81.4 cm.*

Ornamental brooch by René Lalique (1860-1945), gold enamel, diamonds and moonstones, 23x26.6 cm.

SINTRA

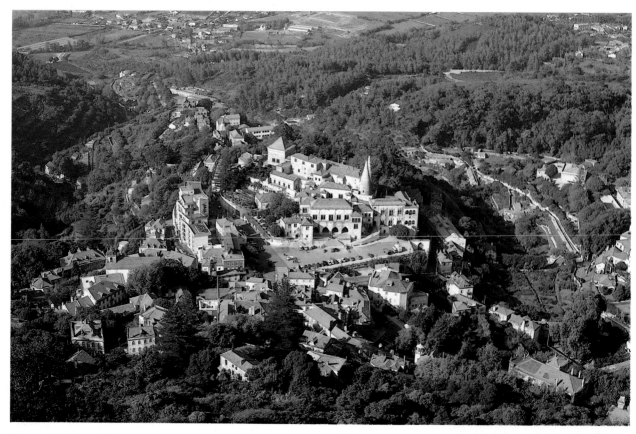

Panoramic view of Sintra.

A tile-clad fountain on the approach to Sintra.

The chimneys of the Royal Palace are believed to be built in a Moorish style.

Palácio Nacional de Sintra.

PALÁCIO DA VILA

With gardens that enchanted kings and inspired poets, as well as artists through the ages, especially in the nineteenth century, Sintra has long been a favourite. Its name - originally Chintra - comes from Arabic, although its roots have long been forgotten and its legends confused. Among those who have succumbed to its delights are Luís de Camões, Almeida Garrett, Eça de Queiroz, Lord Byron and William Beckford.

In Monserrate, courtiers used to flit in and out of the many shrubs growing in the gardens, and the area retains a magical quality even today.

Suddenly, the landscape juts sharply upwards. It is covered in dense forest, and marks the end of the west coast at Cabo da Roca - the westernmost point of Europe, not counting the Azores. The Sintra hills offer the promise of a journey into times past.

In the heart of the town, which is some forty kilometres from Lisbon, there are still traces of the Muslim occupancy of Portugal, with houses with open patios surrounding fountains. The National Palace is situated in the main square, in the midst of arcades, ceramic tile decor, medieval, Renaissance, Baroque and romantic

buildings. Little is known of its roots, although there are those who claim that it was inhabited by Arab chiefs. In spite of the many different views and opinions on the question, the palace was undoubtedly enlarged during the reign of King Dinis.

What is also certain is that members of the court spent part of their leisure time there from the time of the Troubadour King. The Aviz dynasty turned the palace into a summer retreat, although keeping the architecture on the same lines.

It was in the palace, then very different from the opulent building of today, that the first expedition to Ceuta was planned. Later, João I received envoys from Philip the Good of Burgundy - amongst whom was the Flemish painter Jan van Eyck - to arrange his marriage with the Infanta Isabel. This is commemorated in one of the rooms: Swans, which were symbols of the house of the groom, were painted on the ceiling, one for each year of the bride's age.

Other ceilings also feature birds such as the Magpie Room. Each magpie - also denoting a courtesan in Portuguese - bears the expression "Por Bem" - all for the

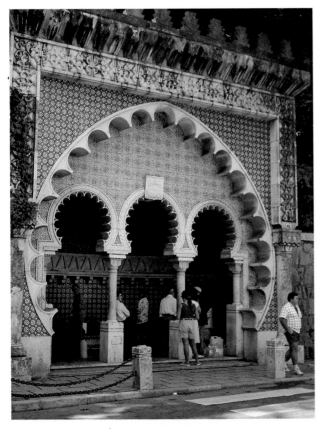

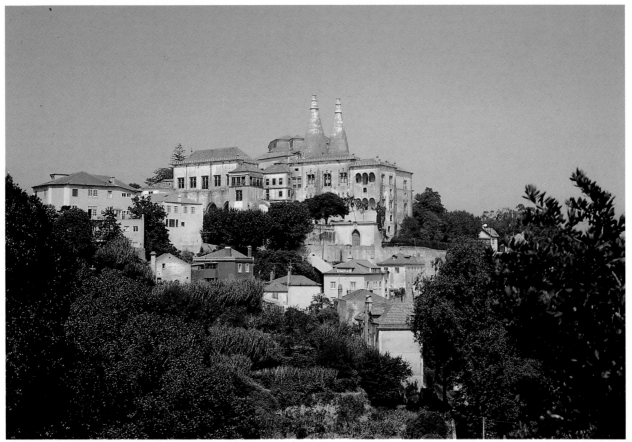

good - written on it. This was the inept excuse offered by João I when Phillipa of Lancaster caught him kissing one of her ladies-in-waiting. Because of the rumours and intrigue that followed, the king had the ceiling painted with 136 magpies - one for each lady-in-waiting.

The palace's Gothic chimneys are a sign that the court of the early Aviz dynasty spent much of their time there in some splendour. Eye-catching, the chimneys are gigantic cones and can be seen for miles. They must have provided a more than adequate outlet for the smoke which came from the endless preparation of food in the enormous kitchens.

Afonso V, who died here in 1481, built on to the palace. João II was proclaimed king here, and showed a marked preference for the location, spending many a summer in the royal residence. He too carried out renovation work on the building. However, most of the work was done during the reign of Manuel I between 1505 and 1520. The eastern wing was added and is typical of the art of that time. Twin windows were also added, decorated in luxurious Gothic-naturalist ornament, as well as the rounded arches in the galleries. The Salão dos Brasões dates from the same period - 72 coats-of-arms of the nobility at that time are shown. The room's cubic struc-

Renaissance fountain at the entrance of the Palácio Nacional de Sintra.

Hall of Stags.

Hall of Magpies.

Hall of Swans.

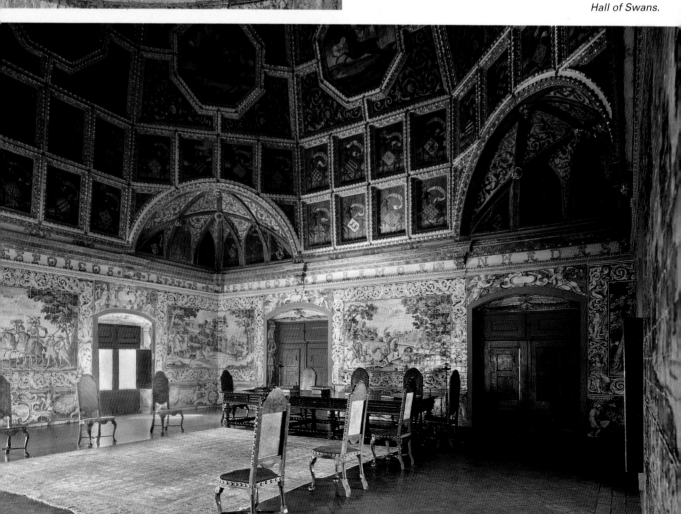

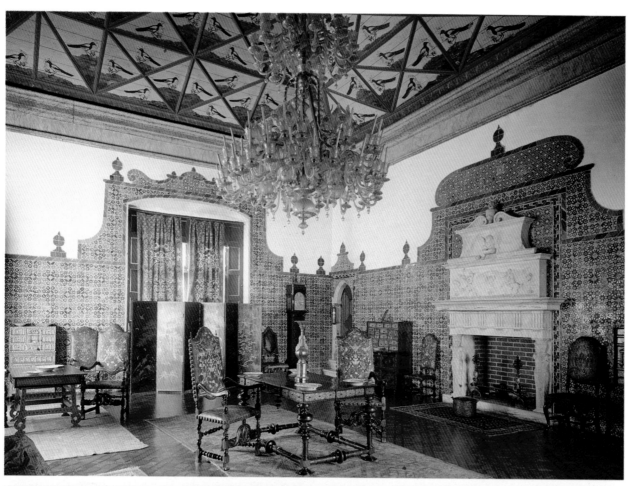

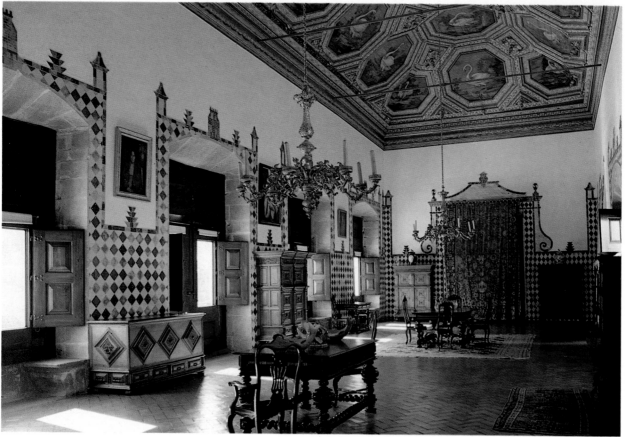

ture and high pyramid-shaped ceiling are typical of the Manueline style. Under the Moorish cornice is a large honeycombed frieze.

The palace houses has the largest and most important collection of antique *azulejos* in Portugal. Of note are the Swan and Magpie Rooms, which contain rare examples in azul-de-fez, the Arab Room, tiled with the chequered Seville wainscots and the Manueline azulejos with fleurs-de-lys and sheaves of corn, which decorate the frieze. The beautiful Gothic chapel also deserves special mention, with its Islamic ceiling and traces of Gothic paintings.

The palace has been the scene of many events and countless styles have merged here - it was in the palace that the Infanta Maria, sister of João III, had her ladies' court, a place of culture where the ladies spoke Hebrew, Greek and Latin. All this has contributed towards the palace's delightful aura, which can still be felt.

For all that, one of history's most painful episodes is engraved in the floor of a small side room. This was the prison of Afonso VI for the last nine years of his life, where he died in physical and mental agony.

Largo Rainha D. Amélia viewed from the Palace entrance.

Wandering through the narrow streets and alleyways, the town appears very picturesque.

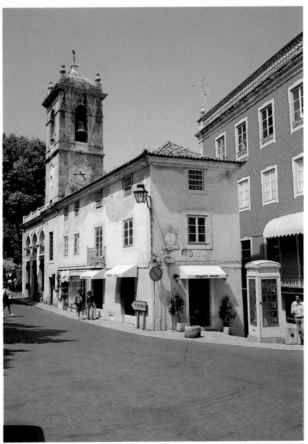

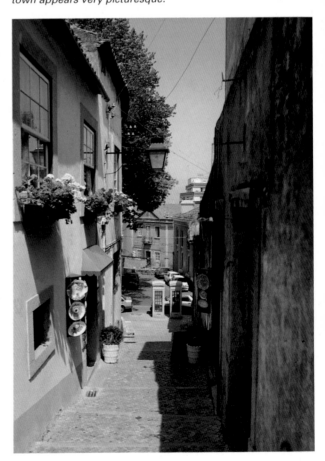

General view of Palácio da Pena.

PALÁCIO DA PENA

The Sintra hills can be seen for miles, rising into the sky like a towering fortress, adorned here and there with houses, mansions and other buildings. The Pena Palace sits on the top of one of the peaks, like a crown. What is left of the grey ramparts of the **Moorish Castle** snakes through the green of the forest. The castle was built in the eighth or ninth century by the Arabs, and was taken in 1147 when Afonso Henriques extended the power of the Christians as far as Sintra. The ramparts, which were rebuilt during the reign of Fernando I, have been changed over the years due to restoration work and damage inflicted by the earthquake of 1755. Fernando II also carried out work on the ramparts and some of the towers, and this is what can be seen today. However, the interior still retains some pre-Romanesque remains of a chapel which possibly dates from before the Reconquest.

On the top of the next hill there was a grotto where the Virgin Mary is said to have appeared. A small chapel was built there dedicated to Nossa Senhora da Penha. Priests from the Church of St. Mary of Sintra used to celebrate mass there every Saturday, by order of João I.

In 1493, João II came to the chapel, accompanied by his wife, and spent eleven days here, in fulfilment of a vow. Manuel I was also devoted to the saint. He ordered the cliff to be cut so as to create a small terrace on which he built the Monastery of the Hieronymite Monks, constructed entirely of wood, to replace the tiny church. Work began in 1503. Barely eight years later, the king decided to rebuild with stronger materials. A beautiful building was constructed out of stone. It had a dome, and also contained a chapel, sacristy, bell tower, workshops, cloisters and a dormitory big enough to accommodate 18 monks.

The design of the monastery is sometimes attributed to the Italian architect Giovanni Potassi, although there are those who claim it was Boytac. Manuel I spent an enormous sum on the project. In the chapel, it is still possible to see the royal coats-of-arms, on the ceilings, surronded by guilloche tracery and the great deeds of the king, illustrated in the *azulejos*.

João III and Queen Catarina also showed great devotion to Nossa Senhora da Penha. They installed the Renaissance retable of jasper and alabaster. It is decorated with images and bas-relief, showing scenes from the New Testament and the Passion of Christ. It is said to be

by Nicolas de Chanterenne, or Nicolau Romano, and was commissioned for the chapel's high altar in 1532, to give thanks for the birth of the Infante Dom Manuel.

On 30 September 1743, lightning destroyed part of the tower, chapel and the sacristy. A few years later, the earthquake of 1755 caused grave damage. In the first quarter of the nineteenth century, the French invasions made their own nefarious contribution to the destruction of the building. The wars between Liberals and Absolutists also helped to destroy it. The coup de grace came in 1834, when religious orders were disbanded, and the monastery was abandoned.

Four years later, Fernando II, prince of the house of Saxe-Coburg-Gotha and husband of Maria II, was in love with Portugal and acquired the ruins. He had a fine artistic sense, and was determined to restore the

The magnificent Palácio da Pena stands at a height of 500 m in the middle of the Serra de Sintra.

The Arabic Gate and drawbridge.

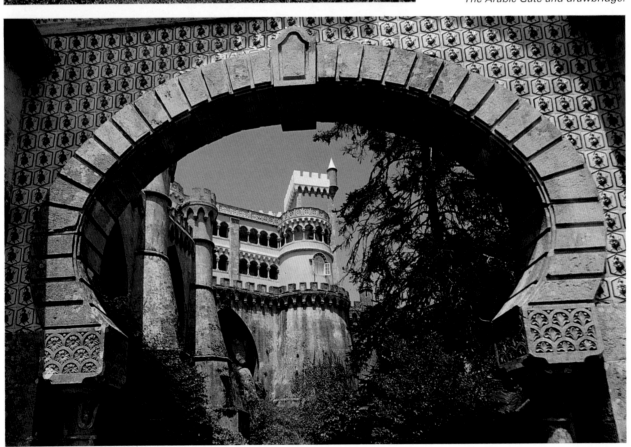

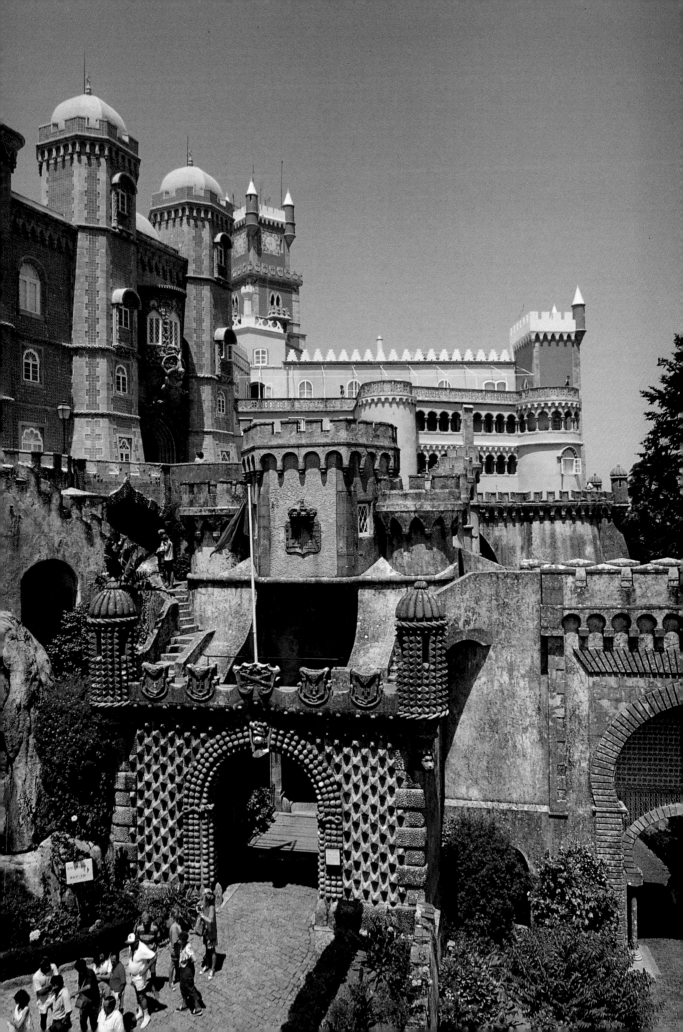

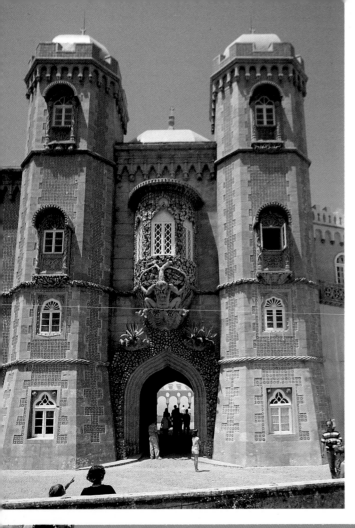

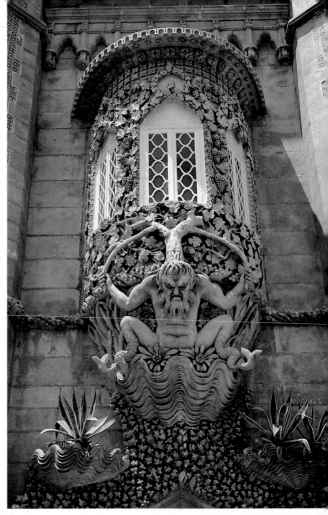

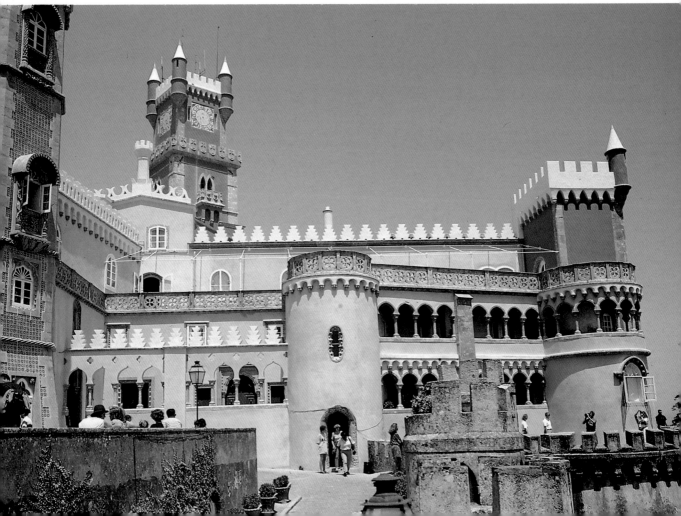

ruins and make it a summer residence. However, influenced by the artistic Baron von Eschwege - who later designed the park together with Wensceslau Cifka - Fernando decided to build a beautiful romantic palace, which would fit in well with what was left of the sixteenth century building.

Construction began in 1840, starting with the road that is still used today to reach Pena Palace. In 1844, work got underway on the building, headed by the Italian Demetrio Cinnatti.

The palace is the embodiment of a romantic ideal, and much more than a simple monument. It is a blend of rare harmony, despite the revivalist potpourri of styles. Built three decades before the castles of Ludwig II of Bavaria, it is the exponent of an age when the dreams of the powerful prevailed. Through one's eyes, one is transported to ancient Egypt, represented by the plant and animal motifs, cymas and columns; on to the Arab countries by way of the minarets and arches - not to mention the interior of some of the rooms - and the Middle East, represented by the statue at the entrance and in the two-storey cloisters, (although they are decorated with ceramic tiles dating from the Hispano-arabs to the nineteenth century). The Gothic style is present in the chapel and the cloisters, and at the summit of the domes. The Renaissance influence is apparent in motifs such as the pointed tops of the sentry boxes and the afore mentioned sixteenth-century retable.

The palace also has countless magical motifs included in its decoration. A good example of this is the Triton Gate, covered in waves of coral and shells, which also supports the earth, as symbolised by the fruit-laden vines.

The irregular layout of the palace, which is in keeping with the exterior, with its magnificent greenery, does not limit itself to the glories of architecture. The **interior** is also dazzling, and displays Portugal's history together with the world with which it developed. The art of many of the nations Portugal had contact with are represented there, such as India and the Far East, as well as Africa and Europe. The interior contains fine pieces of furniture, china, sculpture, paintings and other treasures. The National Palace of Pena is the sumptuous waking expression of the splendour of a dream.

Following pages, Palácio da Pena: the Ballroom, Queen Amélia's Room, the Chapel and Clock Tower.

Palácio da Pena: Triton Gate; Triton Window. The Palace is a mixture of Gothic, Manueline and Moorish styles, as well as Renaissance and baroque elements which merge with varying degrees of success.

Arabic Room.

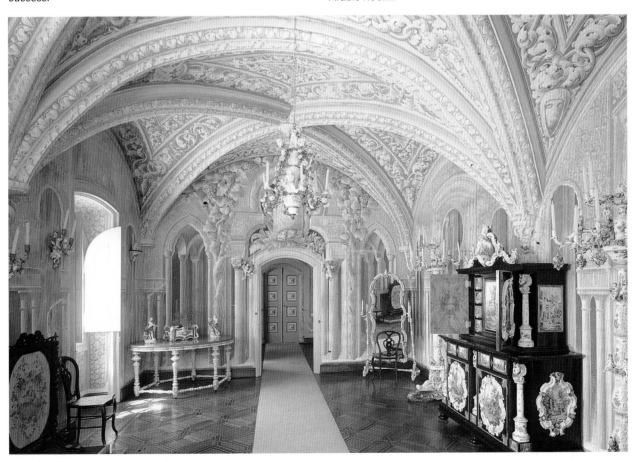

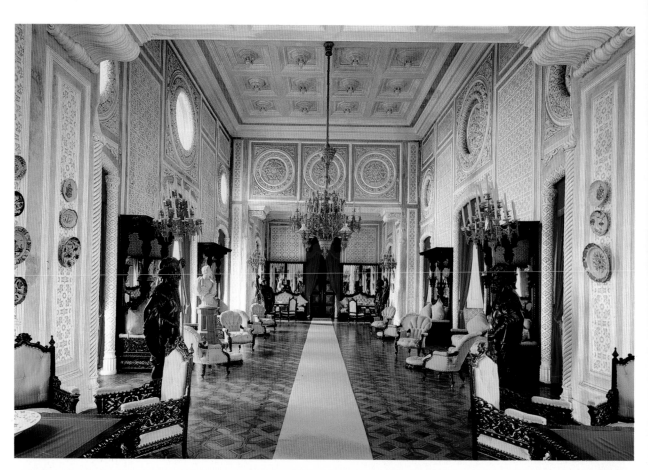

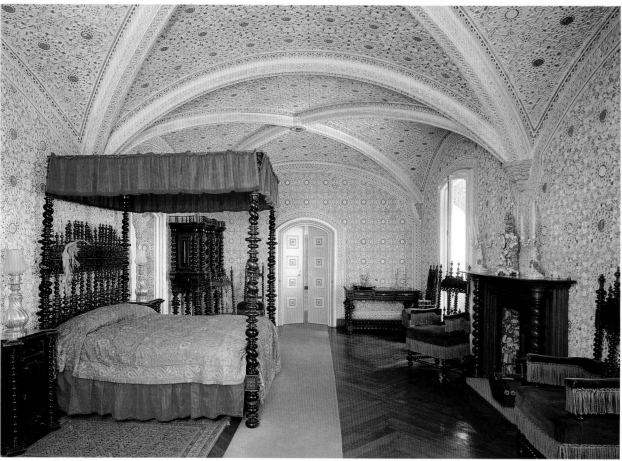

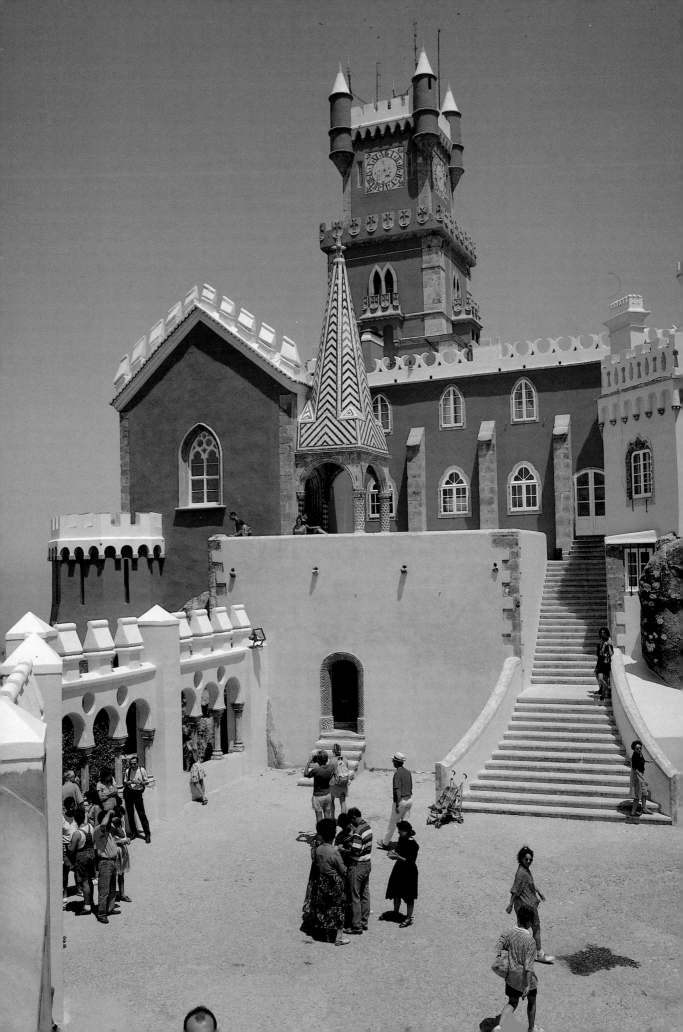

QUELUZ

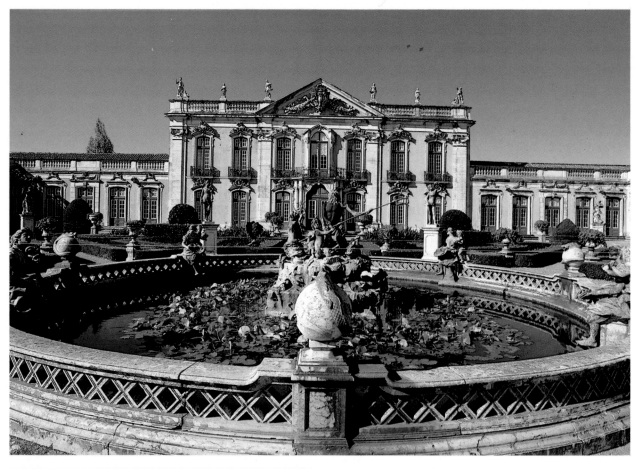

Palácio Nacional de Queluz: Fountain of Neptune (1763) and the Cerimonial Façade (1764-67).

The central group in the Fountain of Neptune.

Ambassadors Room (1757-62).

Throne Room (1768-70).

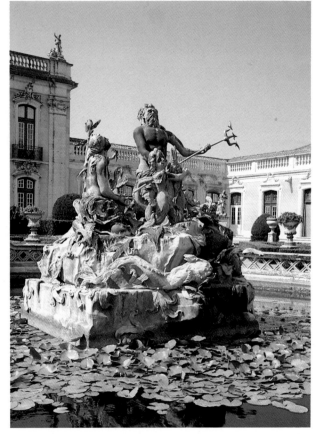

PALÁCIO DE QUELUZ

The National Palace of Queluz is the most attractive and famous eighteenth century house in Portugal. Building started in 1747 on the site of a manor house belonging to the first Marquis of Castelo Rodrigo, and continued until 1786. The first stage, completed in 1758, involved the construction of the monumental facade.

Talented artists were commissioned to carry out the work, and only the best materials were used. The design is by the architect Mateus Vicente de Oliveira. His work was continued by the Frenchman Jean Baptiste Robillon, who decorated the interior and also extended the building westwards, designed the neo-classical main facade and the gardens. The chapel was built into the structure at the same time, and is decorated with gilt wood carvings by Silvestre Faria Lobo.

The palace is mainly Baroque, although it also has *rocaille* decoration, such as the balustrades with statues

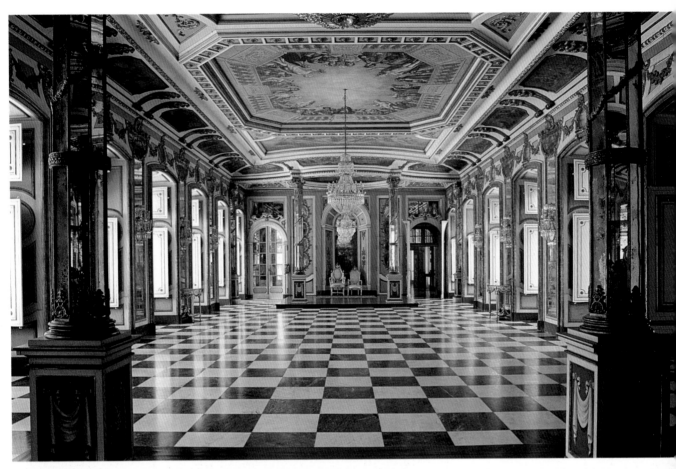

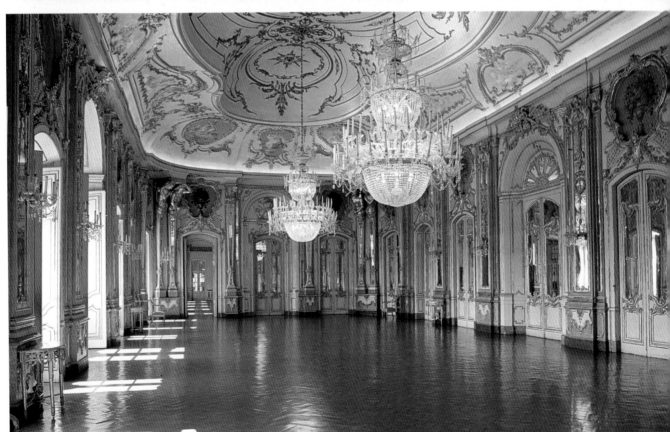

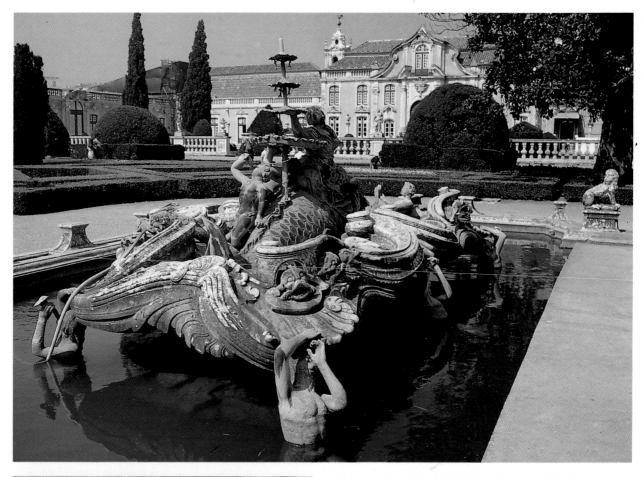

Fountain of the Nereid (1778) and Façade of the Throne Room.

Marble sphinx before the Portico of Fame.

and the heraldic pediment. The palace extends further into beautiful gardens, which bear witness to the aspirations of the court wanting pomp on a European scale, in keeping with the fashion of the time. This can also be seen in the ceramic tiles in the gardens, depicting scenes of court life at Queluz.

In 1794, when a fire destroyed the Palace of Ajuda, Queluz was transformed from a summer residence into the permanent home of the royal family, and the scene for official receptions.

In 1807, when the royal family left for Brazil, they took with them the majority of the contents of the palace. When Junot, the leader of the Napoleonic armies, took up residence, alterations were made in the rooms and some furniture was replaced. When the royal family returned from exile in 1821, they were determined to go back to Queluz, but it was not to be. During her reign, Maria II used the palace for rest and recreation.

Today, Queluz is the scene of activities intended to restore the palace to some of the splendour it enjoyed in its eighteenth century court life. These activities include concerts and displays of dancing. The palace's rooms, filled with paintings and Italian marbles, the magnificent floors made from Brazilian wood and the gardens testify to the great beauty of Queluz.

CASCAIS

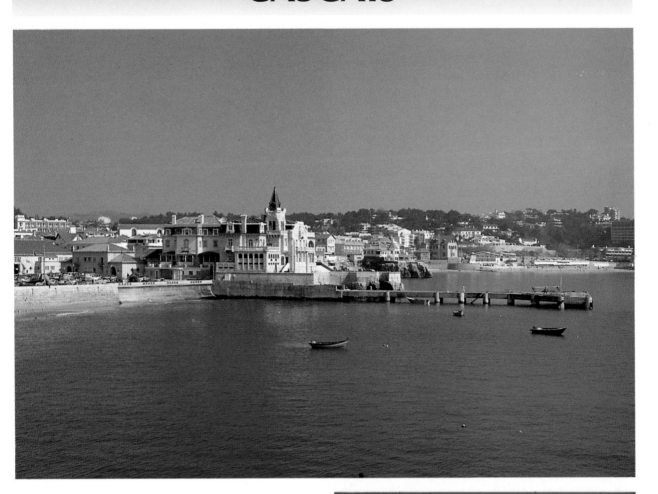

A view of the town and its harbour.

Bronze statue of D. Pedro I (1320-1367) on Largo 5 de Outubro.

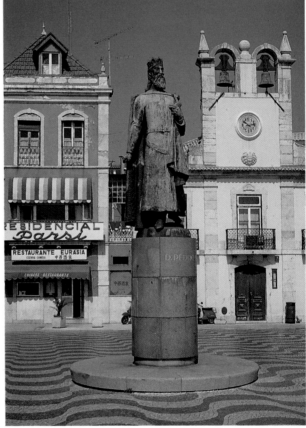

The Roman *Cascale* was later an Arab town, and was in turn conquered from them by the Christians, during the reign of Afonso Henriques. Its history is studded with events of different ages and a diversity of styles, as can be seen in the buildings: medieval, Renaissance, Baroque, Romanesque and modern. Modest houses stand beside palaces, churches and hermitages, forts and there is even a citadel.

Cascais enjoys a beautiful location facing the sea. The town, surrounded by hills and white sandy beaches, is protected by the lovely countryside, and was for a long time known as the land of kings and fishermen. Several monarchs spent their summers here, taking in the delights of the picturesque little town. Further along the coast is Boca do Inferno - Mouth of Hell - a rocky crater where the sea pounds in.

Cascais has many monuments, among which the **Church of Nossa Senhora da Assunção** deserves special mention. The ceiling over the nave has paintings by Malhoa and the wall space is shared between *azulejo* panels dating from 1748, illustrating scenes from the Apocalypse and the life of the Virgin, and paintings by Josefa de Óbidos. There are also sixteenth century paintings in the chancel attributed to the Mestre da Lourinhã.

In the old fishing village of Cascais, there is fittingly a

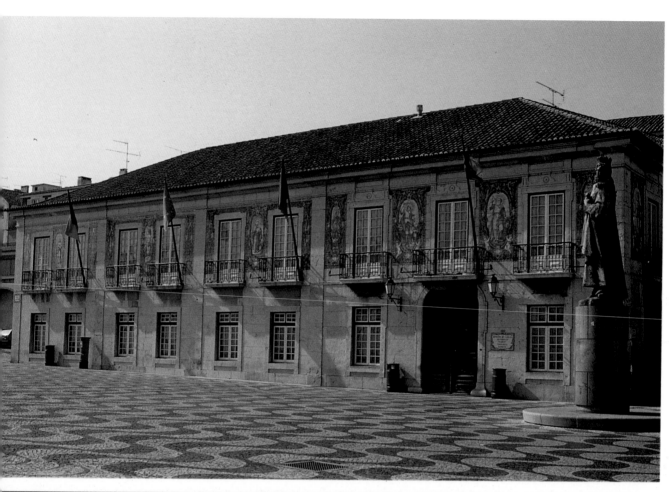

Baroque church dedicated to *Nossa Senhora dos Navegantes* - Our Lady of Sailors. The church, has a surprising octagonal layout, and an interior decorated with white, pink and grey marbles. The two hermitages which figure in local history, are the seventeenth century *São Sebastião* - which is in the Museum and Library of the Counts of Castro Guimarães. This was opened in 1932 and houses a beautiful collection of paintings, Indo-Portuguese furniture, archaeology, and a magnificent library - and the *chapel of Nossa Senhora da Guia*, where the Manueline portal and the seventeenth- and eighteenth-century *azulejos* are particularly interesting.

Examples of ceramic tile art can be found almost everywhere. The Town Hall, for instance, contains some lovely panels. The two seventeenth century forts are fine examples of military architecture. They were built as part of a defence plan for the river Tagus.

Cascais has grown thanks to the hotels and restaurants which have sprung up to cater for the many visitors to the town. It is often host to live concerts, and the Cascais Jazz Festival.

Tile panels (XVIII c.) decorate the façade of the Town Hall, the former palace of the Condes da Guarda, on Largo 5 de Outubro.

St. Paul and St. Peter depicted on tile panels at the Town Hall.

The Tower of St. Sebastian in the former country residence (1906) of Conde de Castro Guimarães which houses a library and small museum.

Azulejos panel (1750) composed of 980 tiles depicting a Sermon for various religious Orders, at the Lion Fountain in the museum gardens.

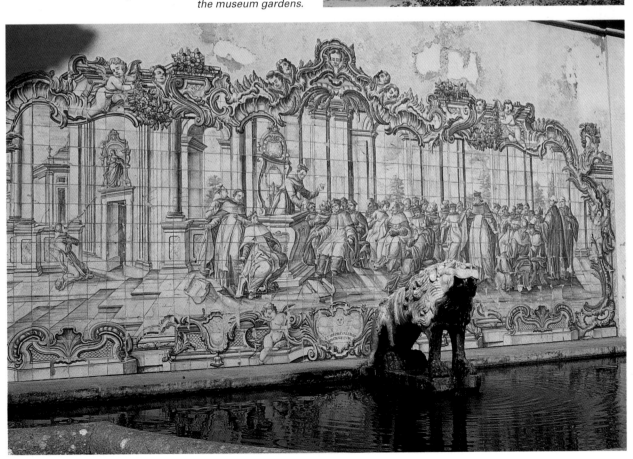

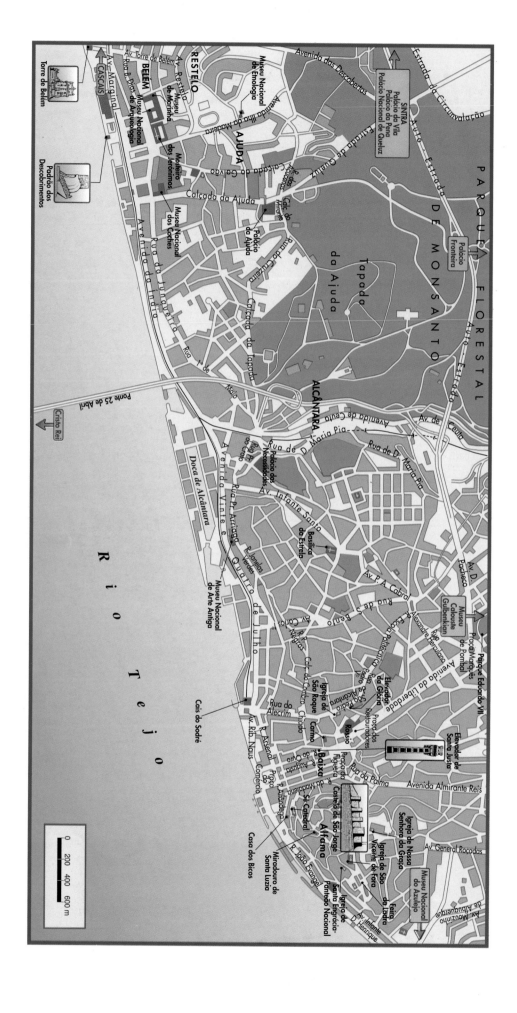